Weathering the Storm

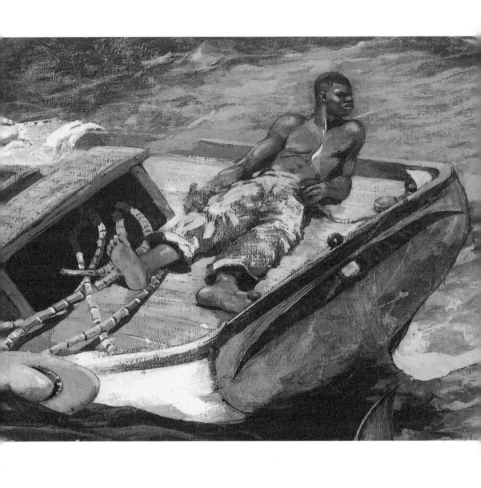

Weathering the Storm

Inside Winslow Homer's *Gulf Stream*

PETER H. WOOD

Mercer University Lamar Memorial Lectures No. 46

The University of Georgia Press ATHENS *&* LONDON

Designed by Erin Kirk New
Set in 10.5 on 14 Monotype Garamond by Bookcomp, Inc.
Printed and bound by Maple-Vail

The paper in this book meets the guidelines for permanence and durability
of the Committee on Production Guidelines for Book Longevity of the
Council on Library Resources.

Printed in the United States of America

08 07 06 05 04 C 5 4 3 2 1

Library of Congress Cataloging-in-Publication Data
Wood, Peter H., 1943–
Weathering the storm : inside Winslow Homer's Gulf Stream / Peter H. Wood.
p. cm. — (Mercer University Lamar memorial lectures ; no. 46)
Includes bibliographical references and index.
ISBN 0-8203-2625-9 (hardcover : alk. paper)
1. Homer, Winslow, 1836–1910. Gulf Stream. 2. African Americans in art.
3. Social problems in art. 4. Painting, American—19th century—Themes,
motives. I. Homer, Winslow, 1836–1910. II. Title. III. Series.
ND237.H7A65 2004
759.13—dc22
2004001270

British Library Cataloging-in-Publication Data available

In memory of my parents,

William Barry Wood Jr.

and

Mary Lee Hutchins Wood,

who were both infants in Boston in the fall of 1910

when Winslow Homer died at the age

of seventy-four

When we try to look at the inheritance of Atlantic slavery, what we are capable of seeing remains to be seen.

—Marcus Wood, *Blind Memory*

Contents

Illustrations

Acknowledgments

In October 2002, I had the honor to deliver the Lamar Memorial Lectures in Macon, Georgia. The three Lamar Lectures at Mercer University offered me an opportunity to talk at some length about an artist and a picture that have fascinated me for years. I spend most of my time teaching early American history at Duke University, but nearly a quarter century ago I prepared a talk on *The Gulf Stream* for a conference at The Citadel in Charleston, South Carolina. Since then, I have continued to write and lecture about Winslow Homer's black images as time permits, because the subject allows me to combine my lifelong interests in American art and African American history. At one point I worked with Karen Dalton—a wonderfully knowledgeable art historian who taught me a great deal—to write a book about the artist's depictions of blacks and to organize an exhibit of some of his early work. But I had never had a chance to revisit this famous painting.

My sincere thanks, therefore, to all those who helped make this opportunity possible. I am grateful to Sarah Gardner, Mike and Lynn Cass, Beth Sherouse, and other members of the faculty, staff, and student body at Mercer University who made my stay in Macon so enjoyable. I had time to savor the warmth of the 1842 Inn and to explore the nearby Ocmulgee Indian mounds. I even managed to visit the Civil War prison and cemetery at Andersonville, a site that figures in an important painting by Winslow Homer. While on the Mercer

campus, I enjoyed friendly hospitality, lively discussions, and sincere interest in a challenging subject that is dear to my heart. I hope that I persuaded listeners that the format of an annual lecture series can lend itself well to exploring what a scholar friend of mine calls "history in a grain of sand."

I also hope that I convinced my audience that a lectureship dedicated to "southern culture, history, and literature" is a suitable setting to reexamine a profound maritime painting by a New England–born artist. Certainly, the complexities of the southern past loom large in my talks and add some crucial and somewhat unfamiliar ingredients to the discussion of a famous work of art. I presume to think that the founder of the lecture series, the late Eugenia Dorothy Blount Lamar, would have understood this approach. Growing up in Georgia and attending college at Wesleyan and Wellesley, she must have appreciated better than most of us the intricate connections between North and South, and between American art and American history.

Any discussion of Homer's work should be rich with images. These talks were presented as slide lectures, and I have left in the text the names of numerous pictures. I hope that readers will seek them out on the Web or delve into the many handsome books that contain abundant Homer reproductions. I am particularly grateful to the Lamar Memorial Lectures Committee for helping to bear the added cost of illustrating this volume. Thanks also to the museums and collections that have allowed their works to be reprinted, especially New York's incomparable Metropolitan Museum of Art.

This book is intended for a wide audience: anyone familiar with Winslow Homer, plus others who do not know his work. Like any author discussing Homer, I owe a great deal to the first-rate scholars, biographers, and curators who have written about his life and work over the years. They are too numerous to name, and my debts to them are far more substantial than occasional endnotes can suggest. I hope that the book, though written for a broader public, will also spark

their interest. I look forward to working with some of them on the important Winslow Homer film that Steven Ross is now preparing. The editors and staff at the University of Georgia Press have taken a keen interest in this project. I am grateful to them and to all the friends, colleagues, students, and listeners who have shared their enthusiasm and insights concerning Homer over the years. Thanks to Lil Fenn for helping to make this a better book; I can never thank her for everything else.

Introduction Diving into the Wreck

To see what is in front of one's nose needs a constant struggle.
—*George Orwell*

Many years ago, during my first year in college, I had the good luck
to enroll in a small freshman seminar in art history with a young and
energetic teacher. I had already fallen in love with American history
and knew I was headed in that direction, but I had enjoyed a large
introductory art history class and was eager for more. We met once a
week in the museum, and throughout the semester we concentrated
on only two pictures, a French allegorical painting and a Dutch forest
landscape. At class time, we gathered in front of the image to study
it and talk about it, comparing our perceptions and ideas. Then we
would depart, using the rest of the week to make comparisons with
other works, explore different readings, and draft short papers or pre-
sentations about our thoughts and findings. The next week we would
return to the same spot to reexamine the picture. Talking together, we
dug deeper and opened up further layers of meaning. It was an un-
forgettable experience, and it taught me the satisfaction of remaining
in one place and concentrating on a single object.

Sometimes it is exciting to stay put. Though we rarely give our-
selves time these days, it pays occasionally to *dwell* on something—to
reread a book, to reconsider some long-held idea, or to contemplate

a valued picture again and again. Now and then we hear a minister or a rabbi illuminate a familiar passage or we revisit a favorite place or story. But as Americans we spend most of our lives, from an early age, in a headlong rush. We are always moving on, both physically and mentally; so much ground to cover, so much to be done. Our parents and teachers, our clients and customers, our beepers and cell phones all seem to prod us onward, distracting us from the present with reminders of all that still lies ahead. When the famous historian Henry Adams stood before the whirling dynamos at the Paris Exposition of 1900, he wondered whether the whole world was accelerating too quickly, spinning out of control. It is hard to imagine how much faster he would find our Internet world a century later.

This book offers a chance to stay put. Instead of rushing from gallery to gallery, you are invited to stop and linger in front of a single painting.[1] We shall remain in one place and dig—or rather, since we shall be over water much of the time, *stay in one place and dive.* Revisiting Winslow Homer's *Gulf Stream,* I am reminded of another American artist, Adrienne Rich, who composed a powerful poem more than thirty years ago called "Diving into the Wreck." In it, she describes a difficult sea dive, using oxygen tanks, to reexamine the myths of the past, a dangerous journey downward through the murky layers that, in the poet's words, turn

> bluer and then green and then
> black . . .
>
>
> to explore the wreck . . .
>
>
> We circle silently
> about the wreck
> we dive into the hold.

Rich nudges us to take our own dives of discovery, personal and cultural, to look at things we might prefer to forget. She invites us to

examine, in her words, "the ribs of the disaster," in order to see for ourselves and to better understand in the end

> the damage that was done
> and the treasures that prevail.[2]

Plunging into cold water and diving through murky depths are images that have been applied more than once to exploring the topic of slavery, a subject that looms large in this book. The task of swimming down to the wreck to feel "the ribs of the disaster" and glimpse "the damage that was done" is difficult, whether you are black or white. In a novel called *Foe,* South African writer J. M. Coetzee reworks Daniel Defoe's famous story of shipwreck and survival, *Robinson Crusoe,* so that the black man, Friday, still feels linked to a slave ship from which he escaped as it sank. Though mute and blind, he knows "where the ship went down," and he can "picture the hundreds of his fellow-slaves—or their skeletons—still chained to the wreck, the gay little fish . . . flitting through their eye sockets and the hollow cases that had held their hearts." The reader must take up "the task of descending into that eye" and coming face-to-face with the scene. "Otherwise," Coetzee concludes, "we sail across the surface and come ashore none the wiser, and resume our old lives, and sleep without dreaming, like babes."[3]

Not long ago, an English painter and lecturer named Marcus Wood (no relation to me, I regret) discussed Coetzee's novel, and much else, in a brilliant book called *Blind Memory.* Centering on visual representations associated with the trauma of slavery, Wood explores the relation of powerful art to tragic history. "If the relics of human disaster are limited in their potential to communicate," he writes, "the same is not always true of art. Visual art can transform how we read words, and words can transform images. These interdependencies can be very powerful in the context of slavery." He urges us to undertake difficult dives, to open our eyes to what has been before us all along. I share Wood's sense that where possible we must use history to com-

prehend art and art to fathom history. As we prepare to dive down into the past and look with fresh eyes, I affirm his belief: "the memory of slavery belongs to us all, and requires our acknowledgement, if only we dare to look."[4]

That said, we are ready to start our long descent. Our dive will begin with a discussion of the artist and his famous painting, giving a view of the way the picture has been assessed over the years. In chapter 1, I shall speculate that critics, despite good intentions, have largely "missed the boat" with regard to *The Gulf Stream,* and I shall underscore Homer's complex personal connections to the picture. Diving deeper, we shall then turn southward and examine the stormy era in which the painting was created. Chapter 2 entertains the possibility that the reclusive artist, though living an isolated existence on the coast of Maine, was by no means so cut off from the recent war in Cuba or oblivious to the violent race revolution occurring across the South as has traditionally been assumed. In chapter 3, we venture even deeper down and look further back in time, finally coming into contact with the sunken hulk of slavery itself. It has become a distant and vague recollection for most Americans in the early twenty-first century. But for those who were growing old in the late nineteenth century, slavery remained a powerful memory, so recent and real that only a few, like Winslow Homer, dared to look back at it or contemplate its human costs.

The Personal A Painter and His Picture

No American artist is more familiar, or more widely admired, than Winslow Homer. His pictures hang in numerous museums, appear on calendars, and grace the walls of millions of homes and offices. Almost a century after his death, his art is used more than ever on the covers of history texts and works of literature. In recent years, numerous scholarly books and important public exhibits focusing on aspects of Homer's career have won fresh admiration for the painter among a new generation of Americans. The continuing popularity of Homer reminds us once again that while the artist was a New Englander by upbringing and temperament, he transcended his region, addressing universal themes in ways that still appeal to a wide and enduring audience.

Winslow Homer was born on February 24, 1836, the second of three sons born to Henrietta and Charles Savage Homer, a middle-class couple in Boston, Massachusetts.[1] As a boy, Winslow showed a flair for drawing. He was guided by his mother, a gifted amateur painter, and encouraged by his father, an erstwhile hardware entrepreneur who occasionally brought home drawing books and art supplies for his son. This early support paid off in a long and distinguished career; Winslow Homer had become a well-known and respected artist by the time he died in Maine on September 29, 1910, at age seventy-four. Today, countless people in the United States

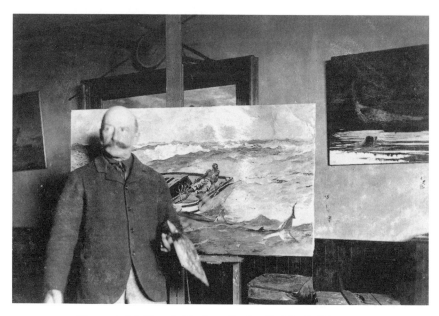

FIGURE 1 Homer in his Prout's Neck studio, beside *The Gulf Stream*, ca. 1900
Albumen print. Bowdoin College Museum of Art, Brunswick, Maine. Gift of the Homer Family
(1964.69.179.9).

and abroad who do not know Homer's name recognize many of his distinctive pictures. The most familiar of all may be *The Gulf Stream,* painted in 1899 (fig. 1), and amended slightly in 1900. The work hangs in New York's Metropolitan Museum of Art (plate 1).[2]

Over a working lifetime of more than half a century, Homer produced hundreds of memorable pictures and developed a unique style that remains easy to distinguish. In addition to being prolific, he also proved to be impressively versatile in the techniques that he mastered. With almost no formal training, he became a skilled practitioner of very different mediums—woodcuts, engravings, watercolors, oils. In an era when advances in printing were expanding the use of graphic illustrations, he learned early to communicate effectively in black and white. Starting at age eighteen, he served a dreary but useful apprenticeship as a sheet music illustrator for a Boston lithographer and printer, J. H. Bufford. Freed from this confining servitude on his twenty-first birthday, he began doing illustrations for a Boston weekly, *Ballou's Pictorial Drawing-Room Companion.*

Homer's obvious promise brought quick recognition. In 1859 he moved to New York City to become an illustrator for *Harper's Weekly,* one of the first popular magazines with a national circulation. The position allowed him to reach wide audiences and earn a decent salary. Editors saw that he could compose realistic and engaging black-and-white pictures on deadline and gave him increasingly important assignments. After the election of Abraham Lincoln in 1860, for example, it was Homer who created the journal's cover image of the new president, based on a photograph by Mathew Brady.[3] When the Civil War erupted he took up the role that would today be played by a war photographer or a television camera person. Early in the war, as an artist with the Army of the Potomac, he drafted images based on his firsthand sketches made in the field. Later, back in New York, he composed pictures based on graphic evidence and written descriptions from the front, supplemented by his own artistic imagination.

But even as Homer honed his talent as an engraver and professional illustrator, he also began to develop his skills as an independent artist using other mediums. He took up serious oil painting during the war years, was elected to membership in the National Academy of Design in 1866, and spent most of the following year in France exploring the Parisian art world and exhibiting his work. An aptitude for using color was already apparent in Homer's early oils, and his talent as a colorist became even more evident in the following decades when he turned to yet another difficult medium, watercolor painting. As a boy he had watched with admiration as his mother painted delicate watercolors of flowers and birds; as a man he emerged as one of the most gifted watercolorists in the Western art world.

Homer came of age in the era of the daguerreotype, and like many other contemporary artists he became fascinated, at times, with freezing a crucial moment, or capturing an unfolding story in a sequence of narrative images. But he also embraced the challenge that faced realistic painters to go beyond momentary snapshots. Again and again, in different mediums, he created pictures that arranged space, light, and color—plus people, animals, and objects—to address larger issues and themes. And he showed equal versatility with regard to subject matter. He explored and mastered at least half a dozen broad signature subjects to which he returned tirelessly and creatively. Over time, his name has become almost synonymous with vivid work portraying each of these important themes.

Homer is perhaps best remembered as America's archetypal painter of sailors and the sea. His pictures of ships and boats, impending storms, breaking waves, and mariners of all ages are varied and memorable. So are his images that center on seashores and coastlines. He was fascinated by margins and drawn to the places where land and water meet. He painted pounding surf, sheltering harbors, steep dunes, and curving beaches. He documented the rocky coast of Maine in

winter and summer. Late in life he captured the sand and coral of Florida, the Bahamas, and the Caribbean in sunshine and storm.

But Homer never confined his art to the sea and the coast. He loved the Adirondack Mountains, the log-filled streams of eastern Canada, and the rivers and bayous of Florida. His work can bring alive a leaping trout, a drinking doe, or a wading heron. Many, therefore, remember him primarily as a painter of nature and the outdoors. His well-known pictures of fishing and hunting feel intimately familiar to anyone who has paddled a canoe, cast for trout, shouldered a gun, or followed a barking hound.

Totally different, but equally central to Homer's reputation, are his numerous pictures of the Civil War and its aftermath. While serving as an illustrator for *Harper's Weekly,* he generated scores of pictures that captured experiences of the war on both the battlefront and the home front. Some of the early images that he composed on the basis of his experience have helped to shape our memory of that conflict, such as the oil painting *Prisoners from the Front* or the sketch of a Yankee sharp-shooter that became both an oil and an engraving for *Harper's* (fig. 2). He not only depicted life in Union Army camps; he also imagined scenes behind Confederate lines, as in *Defiance—Inviting a Shot before Petersburg.* After the war, he created numerous pictures dealing with the difficult struggle faced by soldiers and citizens of both sides to begin life anew. An engraving for *Harper's* in August 1865, entitled *Our Watering-Places—The Empty Sleeve at Newport,* captures the strain on the face of a returning soldier who had lost an arm in the war. An oil painting executed the same year, *The Veteran in a New Field,* shows a former combatant harvesting wheat with a scythe; his motion invokes the "grim reaper" who had recently cut down so many thousands in war.

As if this were not enough, Homer is also remembered for his portrayal of children and adolescence. His vivid and sympathetic depictions of young people—capturing awkward innocence, uncertainty,

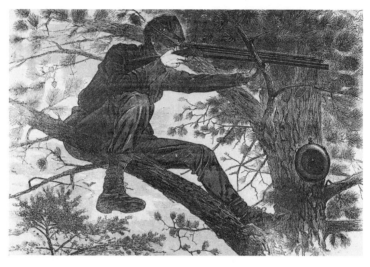

FIGURE 2 Winslow Homer, *The Army of the Potomac—A Sharpshooter on Picket Duty*, 1862

From *Harper's Weekly,* November 15, 1862. 9⅛ × 13¾ in. Collection of Duke University Museum of Art, Museum Purchase, Von Canon Fund (1974.2.76).

and wonder—still bring a rush of memories for adults: the recollection of hiking barefoot through summer grass, squirming at a schoolroom desk, exploring the possibilities of a sandy beach. The popular 1875 painting known as *A Fair Wind* (or *Breezing Up*), in which boys enjoy an exhilarating sail in a fresh breeze, remains one of the most admired pictures in American art.[4] *Snap the Whip,* painted several years earlier, shows a rough-and-tumble game in a rural schoolyard; the scene became a popular *Harper's* illustration, engraved by Homer from his original picture (fig. 3). Likewise, *Boys in a Pasture* has become an icon of childhood in a simpler, preindustrial America. And these are merely three of the best known among a wide array of images that recall nineteenth-century life on the edge of adolescence.

Many of Homer's most engaging pictures of young people feature girls. Indeed, he depicted so many women of all ages—innocent girls, dreamy teenagers, earnest schoolteachers, reflective mothers—that they represent yet another category for which the artist remains well known. The varied figures—always fully clothed—usually appear as strong individuals, independent and pensive. Often they are gazing out to sea or looking intently and thoughtfully at something beyond the frame of the picture.[5]

By any measure, then, Homer's list of distinctive subject categories is impressive and varied: the sea and the shore, the natural world and the world of war, and the somewhat separate worlds of children and of women. Most artists would be proud to know that their work had been admired and had made a lasting mark in any one or two of these huge and timeless areas of human experience. Yet only in the last quarter century has it become clear that there is at least one additional category in Homer's work that cuts across and encompasses all the others. Along with everything else, the artist created varied and distinctive portrayals of African Americans.

Although motive is always difficult to attribute, it is worth noting at the outset that Homer's reasons for painting blacks were complex. In part, like numerous artists, he was attracted to black subjects purely

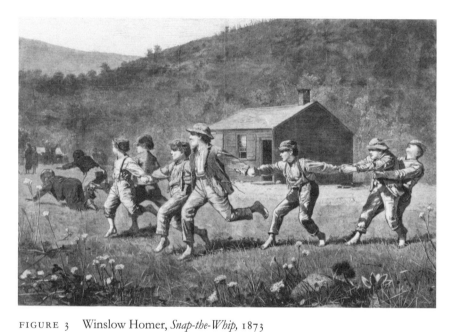

FIGURE 3 Winslow Homer, *Snap-the-Whip,* 1873

From *Harper's Weekly,* November 1, 1873. 9⅛ × 13¾ in. Collection of Duke University Museum of Art, Museum Purchase, Von Canon Fund (1974.2.167).

to meet an artistic challenge. In part, too, like others of his time, he certainly used African Americans to address latent and overt political issues. At a deeper and more abiding level, however, it seems that he found a fascination in blacks and empathized with them because they were forced to remain relative outsiders. To an even greater extent than white women and children, they were obliged to be onlookers in a society dominated (far more than today) by white men. He was drawn to each of these distinctly marginal groups; he identified with them, and he took them seriously.

We shall return to the theme of Homer's depictions of black figures in chapters 2 and 3 because it has obvious relevance for an exploration of *The Gulf Stream*. This extraordinary picture, with a black man at its center, remains almost as enigmatic as it is popular. It hangs in the American Wing of the Metropolitan Museum. In size, it is one of Homer's smaller oil paintings, barely twenty-eight inches by forty-nine inches, but viewers often recall it as much larger, for it is one of his best-known and most memorable works. Ironically, despite its power, it also continues to be one of the least understood.

From the time it first went on display in 1900, *The Gulf Stream* aroused anxious and conflicting emotions in its viewers. Indeed, despite the prominence of its creator, the work went unsold for more than six years. Two women on the board of the Worcester Museum vetoed its purchase because of the picture's "unpleasantness," and it drew nervous laughter from visitors to the National Academy of Design exhibition in Philadelphia in 1906. Nevertheless, the exhibit jury was so impressed that they drafted a letter urging the Metropolitan Museum to acquire the oil. Within three days, museum officials purchased the canvas for $4,500, one of the largest sums Homer ever received for a painting during his lifetime.[6]

The composition received impressive praise from some reviewers. The *Evening Post* called it "that rare thing in these days, a great dramatic picture," and the *New York Herald* described it as "an unusually

strong canvas, even for a Winslow Homer."[7] Numerous viewers applauded the Americanism and realism they found in *The Gulf Stream,* especially in contrast to the works of an emerging generation of artists who had traveled extensively and received their training in Europe, whose "styles seemed over-refined, even effeminate" to many.[8] "There is one American," effused a letter to a newspaper in 1907,

> an old man, who stands out a giant among the degenerates of the age, more virile, more youthful than all the youngsters. Winslow Homer's *Gulf Stream* is one of the great modern pictures. . . . There is no decadence here, no conscious striving for color or brushwork. This masterpiece is honest, virile and rugged, yet not brutal. It is as American in character as Abraham Lincoln.[9]

The muralist Kenyon Cox liked "the dramatic force of the composition," the "admirable mastery of design, and the consequent perfection with which it renders the helpless sliding of the boat into the trough of the sea." Cox praised the painting's structure: "There is not an inch of any of the innumerable lines of the magnificent wave drawing that does not play its part in a symphony of line." What no reproduction can render, Cox continued, "is the superb depth and quality of the blue of the water, or such wonderful passages of sheer painting as the distance, with the ship driving by under full sail, or the dash of spray from the tail of the nearest shark."[10] Lloyd Goodrich, one of Homer's biographers, likewise applauds "the color, the most brilliant in any oil so far, especially the varied range of blues in the water," adding that "the variety and power of its brushwork made it one of his greatest technical achievements."[11]

But there were criticisms as well. Cox noted "a certain hardness of manner in the painting of the whole canvas," and others found fault with "the stocky boat and the figure of the downcast sailor."[12] The *New York Sun*'s critic called the work "huddled in composition" and "too crowded with naturalistic melodrama." He found the picture "less fantastic than cruel" and saw "the quality of the paint as

neither pleasant nor translucent."[13] Homer's initial biographer reports that

> Mr. Riter Fitzgerald, in the Philadelphia "Item," attacked the work savagely, calling it a unique burlesque on a repulsive subject, "a naked negro, lying in a boat while a school of sharks were waltzing around him in the most ludicrous manner." The same writer thought that the artist had painted it with "a sense of grim humor," and that its proper place was in a zoological garden.[14]

Fitzgerald concluded that a favorable review of the picture in the *American Art News* must have been written tongue-in-cheek, and he offered an alternative title for the work: *Smiling Sharks.*[15]

Modern authorities have continued to find fault with *The Gulf Stream.* Art scholar Barbara Novak speaks vaguely of its "illustrative deficiencies" and calls it "one of the most famous but least plastically satisfying of Homer's paintings."[16] In his book on American seascapes, Roger B. Stein says bluntly, "it is not Homer at his best, despite the painting's continuing appeal." Stein finds it "poorly painted, harsh in color, melodramatically overstated and terribly derivative in both its symbolism and its structure."[17]

In spite of the picture's troubling subject, or perhaps because of it, most commentators in the past century have spent inordinate amounts of time admiring and debating the painting's stylistic attributes—color, composition, technique. By focusing so heavily on what Kenyon Cox called "sheer painting," they have engaged in a form of mystification. John Berger, a compelling critic of art critics, describes mystification as "the process of explaining away what might otherwise be evident."[18] Berger concedes that the "compositional unity of a painting contributes fundamentally to the power of its image," but he rightly disparages commentary in which "composition is written about as though it were in itself the emotional charge of the painting." In his book *Ways of Seeing,* Berger contends that such discussions "transfer the emotion provoked by the image from the

plane of lived experience, to that of disinterested 'art appreciation.' All conflict disappears. One is left," he protests, "with the unchanging 'human condition,' and the painting considered as a marvelously made object."[19]

It is thus not surprising that comments on the artistic form of *The Gulf Stream* such as those quoted above have deflected us from deeper issues. Whether early or recent, positive or negative, such commentary has often been used by both writers and viewers to avoid addressing the stark content of the picture. Yet if the painting's stylistic achievements are so debatable, then its persistent power over American audiences must derive from something compelling or resonant in the subject itself.

Of course, no amount of preoccupation with pigments, patterns, and brushstrokes could divert critics *entirely* from Homer's subject matter. Over the years they have tended to offer two contrasting interpretations of *The Gulf Stream*. Both are logical and plausible as far as they go, but whether taken separately or together they remain unsatisfying and incomplete, in large part because the significance of the black man has remained virtually invisible.[20]

One common assessment takes a universal perspective. There is no older or richer artistic image than that of a boat and its occupants at the mercy of the mighty sea. The Greek Homer used the device, and it has been a constant theme in Western painting, shifting in emphasis and meaning according to the times. In the first half of the nineteenth century, both in Europe and in America, it often served as a vehicle for romantic allegories. Homer scholar Nicolai Cikovsky has pointed out that the artist was probably quite familiar with Thomas Cole's *Voyage of Life: Manhood* from 1841 and Eugène Delacroix's earlier study entitled *Dante and Virgil Crossing the Styx,* since both pictures were in the New York collection of John Taylor Johnston in the 1870s, along with Homer's own *Prisoners from the Front.*[21]

Overtones of "tragedy and apocalypse" surrounded this genre in late-nineteenth-century America, reflecting the fin-de-siècle anxiety

over social and cultural drift in the face of a remote deity and overwhelming nature.[22] Albert Pinkham Ryder, Homer's New York contemporary, epitomized this mood in such seascapes as *Jonah and the Whale* and *The Flying Dutchman*. In 1896, Ryder completed *Constance,* a painting based on Geoffrey Chaucer's fourteenth-century story "The Man of Law's Tale" (fig. 4). The narrative, from *The Canterbury Tales,* concerns a mother who is set adrift and survives only through her Christian faith. The painting shows her long ordeal as she floats at sea in a rudderless boat.[23]

In 1899, as Homer was painting *The Gulf Stream,* author Stephen Crane composed a small, untitled poem on the widely felt theme of universal indifference to mankind's precarious condition:

A man said to the universe:
"Sir, I exist!"
"However," replied the universe, "The fact has not created in me
A sense of obligation."[24]

The image of individuals facing an uncaring cosmos was certainly a common one at the time. Homer expert Helen Cooper is one of many art scholars to sense this tone of fin-de-siècle disillusionment behind the creation of *The Gulf Stream*: "The figure is half-naked; the foreground is infested with sharks; and in the seemingly limitless ocean, streaks of blood-red hint of a terrible occurrence." Cooper concludes, "Partly through enigma and ambiguity, partly through explicit detail, Homer suggests a nature infinitely indifferent to the fate of man, with man himself resigned to his lot."[25]

The first and most obvious interpretation of Homer's painting for art critics, then, has been to read the canvas as a sweeping statement on the human situation. Such an approach draws all of us—the artist and the viewers—to the picture because we too are adrift in life's ocean without a sail, a rudder, or a companion. According to this reading, we are each lost at sea in the modern world; we are ignored by remote ships and buffeted by passing squalls, and we have as much

FIGURE 4 Albert Pinkham Ryder (American, 1847–1917), *Constance,* 1896

Oil on canvas, 27⅞ × 35⅝ in. (70.8 × 90.49 cm). Museum of Fine Arts, Boston, A. Shuman Collection (45.770). Photograph © 2003 Museum of Fine Arts, Boston.

hope of controlling our fearful destiny as this luckless mariner. Like Jonah and Constance in Ryder's paintings, it will take Divine Providence to save us, and that seems an unlikely prospect at best.

Art scholar Roger Stein summarizes this interpretation when he dismisses Homer's painting as "a curious pessimistic mélange" of two earlier American paintings, John Singleton Copley's *Watson and the Shark* and Washington Allston's *The Rising of a Thunderstorm at Sea.* According to Stein, "the sharks, the dismasted boat, the lonely and exhausted black man, the bloody water, the distant spout to the right and ship to the left (so mechanically balanced) shout at us in the older romantic rhetoric about how much humans are at the mercy of the sublime."[26] In this interpretation, *The Gulf Stream* is a universal fish story with a Caribbean setting, a precursor to Ernest Hemingway's *The Old Man and the Sea.* The writer was an admirer of Homer's Caribbean art and shared his fascination with the Gulf Stream itself.[27] In 1952, Hemingway published his vivid shark-filled narrative about another man who, to quote the opening line, "fished alone in a skiff in the Gulf Stream."[28]

Like Hemingway's metaphorical tale of his old age, Homer's symbolic statement also lends itself to a different, more literal reading. Cikovsky has pointed out that this and other subject paintings from late in the artist's career seem "stubbornly to defy easy or conventional interpretation . . . because it is never quite clear what *types* of pictures they are, and how, consequently, they are to be understood. Are they narrative (as some of Homer's contemporaries believed, or wanted, *The Gulf Stream* to be) or allegorical? Public or private? Real or imaginary?"[29] From its first appearance, some viewers definitely found the canvas more narrative than allegory, more real than imaginary. A second and almost opposite interpretation, therefore, descends from the cosmic to the specific, tending to see the painting explicitly as a story about an unidentified man caught in an actual storm off the Florida Keys. Faint lettering across the boat's battered transom reads, "ANNA—KEY WEST."[30]

The comparison here is less with Hemingway, perhaps, than with another twentieth-century Nobel laureate in literature, Gabriel García Márquez. In 1955, as a young reporter for a newspaper in Bogotá, Colombia, the author interviewed a seaman who had been swept overboard in heavy seas and drifted for ten days on a life raft in the Caribbean before washing up, half dead, on a deserted beach in northern Colombia. The sailor recounted watching several shipmates drown and surviving thirst, hunger, and searing heat. He watched helplessly as a passing ship failed to notice his distress and as "a riot" of hungry sharks—"the biggest I had ever seen"—circled around the raft. García Márquez turned the seaman's narrative into a first-person account that appeared initially as fourteen dramatic newspaper installments and later as a short book entitled *The Story of a Shipwrecked Sailor*.[31]

While Homer could not know such twentieth-century stories, he certainly knew of earlier incidents, especially those that had prompted great paintings. Théodore Géricault's *Raft of the Medusa* and Copley's *Watson and the Shark* were both famous pictures that dramatized specific well-known events at sea. Géricault finished his monumental painting in July 1819, just three years after the survivors of the *Medusa* disaster had been rescued from their raft by a passing ship. In preparing the picture—originally called *Scène de Naufrage* (scene of shipwreck)—the young Frenchman interviewed several who had endured the ordeal and even persuaded the ship's carpenter to make a model of the original raft.[32] Copley's picture, completed in 1778, immortalized an earlier incident in Havana Harbor. In the foreground, the Boston-born artist showed the young Englishman, Brooke Watson, at the moment of a ferocious shark attack that cost him his leg. (In the background are local Cuban landmarks, including Morro Castle, which Homer himself would later paint.)

Homer portrayed many such explicit anecdotes in his own work. After all, he had cut his artistic teeth as a wartime illustrator sketching Union Army scenes, and more than once he recorded specific mar-

itime disasters. In 1881, he had witnessed and sketched the wreck of the *Iron Cross* at Tynemouth, England, and he later turned his drawing into a studio picture. In 1903, he watched the tragic breakup of the schooner *Washington B. Thomas* on the rocky shore near his studio in Prout's Neck, Maine. Five years later he transformed the incident into *The Wrecked Schooner,* which now hangs in the St. Louis Art Museum. It is thought to be his final watercolor and is considered by many to be one of his most powerful.[33]

Homer also knew tropical storms. He had, as he boasted, traversed the Gulf Stream ten times when he painted *Hurricane, Bahamas* (fig. 5) in 1898, a year before he undertook *The Gulf Stream.*[34] During one of those trips the artist might well have heard or read some specific anecdote that sparked his imagination. Such stories were commonplace in the popular press. In 1888, for example, Lafcadio Hearn published a story in Homer's old magazine, *Harper's,* on a Gulf Coast hurricane. In August 1893, an even larger series of hurricanes ripped along the coast above Savannah, Georgia, taking between three thousand and six thousand lives in Charleston and the Sea Islands. Six months later, Joel Chandler Harris produced an illustrated report on the infamous storms for *Scribner's,* another popular periodical. The two installments, paying considerable attention to loss of life among black coastal fisherman, were entitled "The Devastation" and "The Relief."[35]

At Key West, a place Homer could claim to know well, a whole fleet of small boats known as "wreckers" regularly put out in bad weather to assist larger ships caught in rough seas, and harrowing stories about the fate of such sloops and their crews must have been common.[36] By this second interpretation, then, *The Gulf Stream* is a simple, if horrifying, anecdote. It concerns a specific boat, the *Anna* out of Key West, and it underscores—to quote from a brief paragraph about the picture on the website of the Metropolitan Museum—"the perils of the sea."[37] Homer's first biographer, William Downes, calls the picture "elaborately literary . . . frankly a story-telling piece of work."[38]

* * *

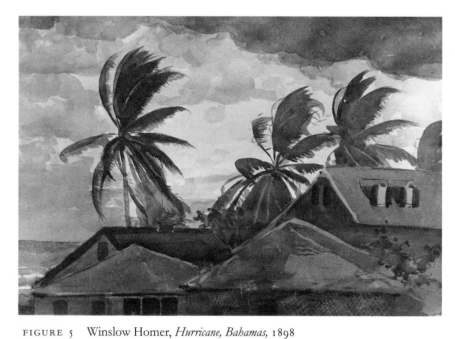

FIGURE 5 Winslow Homer, *Hurricane, Bahamas,* 1898

Watercolor and pencil, 14½ × 21 in. (36.8 × 53.3 cm). The Metropolitan Museum of Art, Purchase, Amelia B. Lazarus Fund, 1910 (10.228.7).

During the 1980s, a third, more personal and psychological, interpretation of *The Gulf Stream* began to emerge. In a short piece written in 1981, I puzzled over the fact that no one had "yet attempted a thoughtful psychobiography of Winslow Homer."[39] I pointed out that there may well have been purely personal concerns involved in the creation of this picture:

> The sixty-three-year-old artist's forceful and aged father had died the preceding year, and Homer had not painted in oil for eighteen months before beginning *The Gulf Stream*. It is hard to measure the degree of personal grief and artistic release that his father's death brought to the constrained New England painter, but there may have been considerable subconscious identification with the isolated sailor who has survived a sudden storm and is now adrift in familiar but dangerous waters.[40]

Art historian Henry Adams offers a psychoanalytic reading of *The Gulf Stream* in his 1983 article, "Mortal Themes: Winslow Homer."[41] This approach is endorsed by the British scholar Hugh Honour in his majestic 1989 volume for a series entitled *The Image of the Black in Western Art*. Honour acknowledges that the canvas may well "have had a personal meaning for Homer, who painted it shortly after his father's death. It conveys a mood of pessimistic, introspective isolation. The artist who had painted blacks with deepening understanding since the Civil War," Honour continues, "seems here to have identified himself with the figure in the boat, alone on the cruel sea that had been the means of his livelihood."[42]

Recently, another distinguished art historian picked up on the same theme. In her important volume entitled *Winslow Homer: The Nature of Observation*, Elizabeth Johns views Homer's *Gulf Stream* as "a last chapter" in "a motif that had long absorbed him . . . the dangers of violent sea storms" in the unsettled winds and currents of the subtropics. But she goes on to suggest that the "life hanging in the balance in Homer's picture" might in some sense be his own, for he had already

had "musings on his own lifespan" as the weight of years increased. "With his father now dead, and his physical frame so like that of his mother, would he not be the next person in the family to die? He perhaps saw the painting itself as a milestone, for he stands in front of it, in the only photograph we have of him at work in his studio."[43] Homer rarely allowed himself to be photographed, and this was, indeed, the only time he appeared with one of his own paintings (see fig. 1). So this personal interpretation may help explain why Homer posed, bareheaded, in his Prout's Neck studio with the half-finished canvas, literally putting himself into his own picture. He seems very nearly onboard the boat, standing shoulder to shoulder with the beleaguered sailor and directly in the path of the nearest sharks.

If in some sense the parentless Homer is the man adrift, then there are ample emblems of death around him.[44] The cabin entrance has the appearance of a tomb, and the uncovered forward hatch has the shape of an open coffin. The cleat in the bow forms an unmistakable wooden cross, and the fallen sail—not yet painted in the photograph—suggests a canvas winding sheet or shroud. The ropes that once held the mast aloft and now trail uselessly in the water are themselves known as "shrouds" in sailors' parlance. And the mast itself is gone, split off at the base and suggesting, as Cikovsky and Kelly point out, "the common nineteenth-century funerary monument of the broken column."[45] The mast has toppled like a huge tree sheared off in a hurricane, smashing a hole—still unpainted—in the starboard gunwale with the weight of its fall. The bowsprit too is broken off, reinforcing the idea of loss, or perhaps even suggesting a second death. Finally, the red flecks in the water hint that other sailors may already have been lost overboard and devoured by sharks.

Charles Savage Homer Sr., Winslow's father, died at Prout's Neck on August 22, 1898, as he was approaching the age of ninety. The relationship between the two men had been both close and complicated for more than six decades. Charles had always supported his

son's artistic interests, providing Winslow with supplies and instruction books as a boy and boasting of his son's success decades later (fig. 6). But his support for the family had been indifferent. When Winslow was an adolescent, the sometime hardware merchant left the family for California, hoping to find wealth in the gold fields. How Charles traveled is unclear, but his brother Henry ventured to California by ship late in 1849, and he may have done the same.[46] Henry died in Sacramento within months; Charles survived, only to return east empty-handed like so many others. Charles's lengthy absence seems to have had a lasting impact on Winslow. In 1873, when Homer painted a boy on shore staring intently at the ocean horizon, he entitled the watercolor *Waiting for Dad*. The youth, perched in the bow of a beached dory, reappears in a similar picture from that same year, an oil painting called *Dad's Coming*. There, and in Homer's related engraving for *Harper's* (fig. 7), the boy is joined by a mother and child, becoming part of a fatherless family looking out to sea.[47]

In the 1880s and 1890s, as an aging widower, Charles grew dependent on his three sons; Winslow and his two brothers tolerated their father's eccentricities and listened to his constant advice. Far from growing sweetly dependent, their father remained adventurous and bossy, chasing after chambermaids in Boston hotels and telling Winslow how much to charge for his pictures. In occasional caricatures Winslow chided his father's teetotaling, on the one hand, and his "intemperate habits," such as a love of red pepper and his refusal to cut his hair, on the other. Several cartoon sketches made when Charles was in his late eighties show him with flowing hair and a thick mustache. In one he is labeled "Prize Old Man," almost as if a hunter had shot him and mounted his head on the wall like the head of a moose. In another he is wearing a captain's hat, labeled "perpetual youth," and barking orders to Lewis Wright, the family's black servant, regarding how to plant the garden.[48]

The loss of such a dominant figure brought both sorrow and relief to Homer. It may also have brought recollections of his mother's

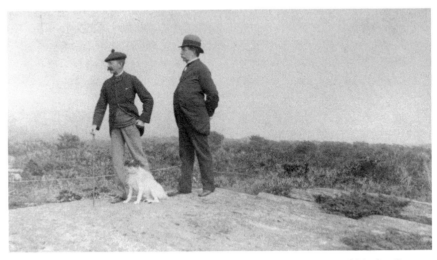

FIGURE 6 Winslow Homer; his father, Charles Savage Homer; and his dog Sam at Prout's Neck, c. 1890–95

Photograph. Bowdoin College Museum of Art, Brunswick, Maine. Gift of the Homer Family (1964.69.153.3).

death fourteen years earlier. She had been closer to him in temperament and more important in his development as an artist. A skilled amateur watercolorist herself, she had shared his interest in painting, and when she died, in April 1884, it was a hard blow for her bachelor son, who was approaching fifty. (The painter would eventually have his ashes buried beside his parents' graves.) Two months after the death of Henrietta Benson Homer, Winslow wrote from Maine to his sister-in-law: "Your kind note with the little box containing Mother's hair I have received to-day. Father found it in his pocket. Although he is not forgetful—he is very well—too well if anything. He looks about for a chip on his neighbors' shoulders. I think he will have a pleasant summer."[49]

Before the end of 1884, Homer traveled to New York, made out a will, and then departed for new and warmer places, visiting Nassau and Cuba for the first time. The independence movement was already brewing in Cuba, and Winslow wrote to his brother from Santiago de Cuba: "This is a red hot place full of soldiers." More trips back and forth across the Gulf Stream would follow. But it was on this initial journey to the Caribbean—less than a year after his mother's death—that Homer first sketched the elements that would later figure in *The Gulf Stream*.[50]

At some point he recorded a quick pencil drawing that includes a man, a boat, and a storm.[51] At another point he created a watercolor called *Sharks* that shows great white sharks swirling around an empty hulk (plate 2). A shark also appears dramatically in another watercolor from the trip, *Shark Fishing—Nassau Bar* (plate 3), which was published as a black-and-white illustration several years later. A further watercolor study, actually called *The Gulf Stream* and thought to be from 1889, shows the same shark associated with a different black man and the familiar listing hulk (plate 4). It includes the dark cloud in the background that had appeared in the pencil sketch. An additional watercolor, *Study for "The Gulf Stream,"* may be from that first southern trip, though more likely it dates from 1898 (plate 5). It

shows crucial details: the broken timbers, the wooden cross, the dark hold, the lifeless shrouds, and the unsettling rise and fall of the sea.

In compositional terms, then, *The Gulf Stream* of 1899 grew from an array of related images and incomplete sketches that Homer began shortly after the death of his mother. In emotional terms, perhaps it was composed in a similar way, bringing together and expressing at last recurrent feelings regarding loss that Homer had experienced over the course of a lifetime. Charles senior's death, a powerful personal event in its own right, may have resurrected the sense of abandonment that Winslow had felt half a century earlier when his father deserted the family to take part in the Gold Rush. Finally parentless, the painter's creative consciousness may have recalled the deep loss he had felt when his artist-mother passed away. In recent decades it has become more accepted to see this compelling image as at least partially a projection of the artist's subconscious feelings of isolation and abandonment. Homer still had command of much, if not all, of his formidable power as an artist. The aging painter was a man of few words, and it is unlikely that he could have expressed verbally the deep and ambiguous feelings that he felt after his father's death. But he could render them powerfully in oil.

Art historian Nicolai Cikovsky summarizes this perspective nicely when he argues that "as great artists often do in their last works," Homer drew upon "an understanding of a lifetime's experiences, deepened by intimations of mortality, laced with memories and (re)-arranged by reflection." Cikovsky suggests that the layers of personal emotion may also have gained shape and force from the fact that they were in tune with the wider sense of drift and uncertainty that pervaded the cultural and political world of the late 1890s. In the book accompanying a monumental retrospective exhibit in 1995, of which he was the curator, Cikovsky writes: "Homer painted *The Gulf Stream* when he was sixty-three years old, in the year following the death of his father, his one surviving parent, and in the last year of the

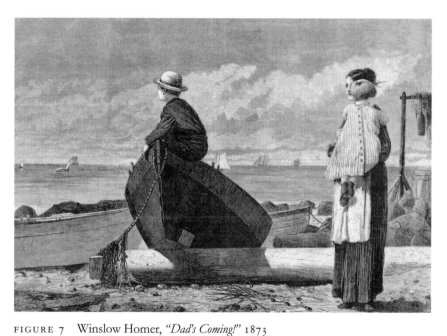

FIGURE 7 Winslow Homer, *"Dad's Coming!"* 1873

From *Harper's Weekly,* November 1, 1873. 9⅛ × 13⅝ in. Collection of Duke University Museum of Art, Museum Purchase, Von Canon Fund (1974.2.170).

century—a confluence of circumstances, despite Homer's advanced age, that might all too easily have caused him to feel, as never before, alone, abandoned, and mortally vulnerable."[52]

Cikovsky expands further on the idea that the painting had significant personal associations: "Emotionally and artistically, *The Gulf Stream* was rooted . . . deeply within Homer himself and in his past." How deeply? Cikovsky suggests that the personal roots of the painting extend back even beyond the death of the artist's mother and the first visits to the tropics in the 1880s, "possibly as deep as one of his first Gloucester watercolors of 1873 and earliest conjugations of life and death. In *A Basket of Clams,* death suddenly intrudes into youthful innocence as two boys, reacting with a mixture of revulsion and fascination, come upon a dead shark washed up on the beach." He notes that "the shark (in virtually the same 'pose') and a listing boat recur a quarter of a century later, recombined as principal parts of *The Gulf Stream*."[53]

After linking the masterpiece to Homer's own earlier works, Cikovsky goes on to connect it to other paintings that Homer almost certainly saw and knew well, including Copley's *Watson and the Shark,* painted during the American Revolution, which also links a black man in a boat to devouring sharks (plate 7). But in the end, Cikovsky may put too much weight on Homer's ties to previous paintings. He depicts Homer's 1899 canvas as "evidence of the retentive clarity of his memory, and, too, of his return by its agency, whether as a willed act or unforced recollection, to distant but still *potently influential experiences of art*." Furthermore, Cikovsky notes, "it is plain that *The Gulf Stream* derives *every distinctive aspect* of its pictorial configuration and the tone and pitch of its . . . expressive effect far more from *remembered experiences of art* than from *actual experiences of reality*."[54]

On this point, as an American social historian with a special interest in southern history and race relations, I find myself somewhat at odds with Cikovsky and other art historians. I welcome suggestions of ties

to the painter's earlier works and to the works of other artists. Like so many others, I continue to be fascinated by the intricate unfolding of the historical tradition of Western painting, as masters build upon masters, reacting to one another's work in surprising and important ways, just as they do in poetry or architecture or sculpture or dance or fiction. Because museums and archives remain the domain where art historians generally feel most at home, this kind of creative genealogy remains their most frequent and effective tool of interpretation. The results can be both elegant and illuminating.[55] Nevertheless, linking art to art remains, by definition, a closed loop, a bounded playing field.

Art historians, therefore, are gradually coming to acknowledge that an awareness of the broader social and historical contexts in which artists experienced life can sometimes open up whole new vistas in interpreting their work. This is particularly true with regard to representational artists, and it offers an intriguing opportunity for historians.[56] For, while painters are surely shaped by the rich art historical tradition of which they are a part, they are also formed by the social, political, and cultural worlds in which they live. And often in great paintings (or novels or sculptures or plays), it is not the *"potently influential experiences of art"* that tell us the most about the creators and their works, but (to rephrase Cikovsky) the potently influential experiences of *life*.

I contend that Winslow Homer's works generally, and *The Gulf Stream* specifically, take on richer and deeper meaning when viewed through the prism of history. In short, any consideration of the painter's *"remembered experiences of art"* is greatly augmented and even altered by an examination of remembered experiences of *life,* of the *"actual experiences of reality,"* that art historians have long overlooked or downplayed in interpreting *The Gulf Stream*. I believe that it is revealing to move away from what John Berger calls the world of "disinterested 'art appreciation'" with its attention to "the unchanging 'human condition,' and the painting considered as a marvelously made object." To repeat the provocative quotation from Berger that I used earlier,

it is my hope to "transfer the emotion provoked by the image" back to "the plane of *lived* experience."[57]

Older interpretations of *The Gulf Stream* saw it as a universal parable on the human condition or, at the other extreme, as an anecdote about a storm off the Florida Keys, the kind of sudden and deadly "white squall" so common in Caribbean waters. Such readings remain plausible, and we can add to them a more personal appraisal of the evocative picture. It reflects a sense of loss and isolation, and it may well capture the artist's subconscious feelings of having sustained a heavy blow in mid-journey, of having been left alone. He could not express such deep emotions directly, but he could shape them into a moving picture. Homer depicted someone else who found himself fearfully down and out, rudderless and adrift without companionship. He painted a person who has weathered a terrible buffeting, an individual whose endurance has already been severely tested and whose very survival is now in question.

But universal, anecdotal, or personal understandings of Homer's memorable painting do not exhaust the possibilities. Indeed, I would argue that they hardly begin do justice to this American masterpiece. To understand it in different, less noticed, and perhaps more important ways, we must dive deeper into Homer's past as an artist and our own past as a nation. We must supplement art history and psychological history with social history and political history. We must leave New England and move south, just as Homer himself did numerous times. In the following two chapters we shall push below the surface, diving into deeper waters. We shall first examine aspects of "the present" that shaped this picture of a black man more than a century ago. Then we shall explore half-forgotten elements of the long American and African American "past" which, when resurrected, give *The Gulf Stream* so much of its abiding mystery and power.

The Present Looking South from Prout's Neck

Winslow Homer's 1899 image of a black man adrift on a mastless and rudderless boat in shark-infested waters is one of the best-known pictures in all of American art. But it has always remained something of an enigma to commentators. Some observers argued, almost from the beginning, that the picture should be viewed as the realistic narrative of a sailing accident—something almost as common and deadly in the nineteenth century as automobile accidents would become in the twentieth century. Others pointed out, with equal cause, that it is possible to regard the work as a melancholy truism about the universal plight of humankind at the beginnings of the modern age.

The fact that the shy artist offered scant guidance on the issue has not impeded efforts by commentators to interpret the painting. Indeed, the silence of the painter from "Down East" has only expanded the prospects for discussion and interpretation. After all, Homer himself spoke and wrote very little about the sources, aims, and meanings of his work. He never married, and he lived alone at Prout's Neck on the coast of southern Maine for the latter part of his life. He left a limited correspondence and granted few interviews, preferring to let his pictures speak for themselves.

Over the years, Homer's images have done just that, speaking to generations of writers. Because the artist was both prolific and diverse during his long career, he gave art critics more than enough to discuss,

and they have been at it steadily for more than a century. An abundance of articles and books have examined the New Englander's work as a whole or explored different periods, aspects, and interpretations of his career.[1] Many of these publications are by experienced art historians, painting critics, and museum curators, and most are carefully documented, suggestively argued, and handsomely illustrated.

Therefore, I was surprised to discover, a quarter of a century ago, that the voluminous Homer literature of the academic art history community had virtually ignored one substantial aspect of the painter's work. With a few exceptions, the cottage industry of Homer scholarship had given almost no attention to the numerous, illuminating representations of blacks in North America and the Caribbean created at various stages of the artist's extended career.[2] Homer's representations of blacks had been given special consideration by the great African American scholar Alain Locke as far back as 1940.[3] But these same images, although well known, remained virtually invisible to white critics. The reality and significance of Homer's depiction of black figures, even in some of his best-known and most striking pictures, had received only brief and passing mention.

In 1981, my own interest in African American history, combined with my lifelong fascination with Homer, prompted me to write an exploratory essay about *The Gulf Stream*.[4] Through a fortunate association with the Menil Foundation in Houston, Texas, I had already become familiar with that organization's unprecedented long-term project, "The Image of the Black in Western Art."[5] I learned a great deal from the project's extraordinary patron, the late Dominique de Menil, and in 1988 I teamed up with a gifted member of the project staff, art historian Karen C. C. Dalton, to write *Winslow Homer's Images of Blacks: The Civil War and Reconstruction Years.* Our book underscored in detail for the first time the fact that African American images constitute a continuous and long-overlooked thread that runs throughout the painter's lifetime. Homer created these images, we empha-

sized, "at every stage of his career and in every medium in which he worked. Among the shy young adolescents, the strong independent women, and the hard-working men who go down to the sea in ships, black figures recur again and again, portrayed with clarity and depth of feeling."[6]

Even before the Civil War, Homer had begun to put black people at the center of pictures rather than confining them to the margins, as so many of his contemporaries did. One of his earliest drawings for *Harper's Weekly* is an 1860 engraving that depicts the black abolitionist Frederick Douglass at center stage in a tumultuous rally in Boston held to commemorate the first anniversary of the hanging of the antislavery martyr John Brown.[7] Blacks played key roles in several pictures that Homer made the following year in Virginia, including one meaning-filled sketch done in ink, watercolor, and pencil. Called *View of Mount Vernon and North Colonnade,* it shows George Washington's once-stately home in disrepair; the only visible people are members of a slave family emerging from a basement door on the north side of the mansion. In an illustration published in *Harper's* on December 21 entitled *A Bivouac Fire on the Potomac,* Homer made a black Virginian the center of attention (fig. 8). The young ex-slave, shown dancing beside a campfire to entertain northern troops, had recently escaped from bondage to become one of the many free black refugees, known as contrabands, who found work in Union Army camps.

Such close attention to African Americans, although certainly not unprecedented, was uncommon among artists of the Civil War era. As the conflict progressed, Homer did more than feature blacks as occasional central figures. He portrayed them increasingly as thoughtful beings with their own perceptions and emotions; he took his viewers inside their minds. Consider, for example, *A Shell in the Rebel Trenches,* a picture the young illustrator created for *Harper's* in 1863 (fig. 9).[8] He had not, of course, actually been in any rebel trenches, and he was still dealing for the most part in broad stereotypes that his audience recognized easily: the unbending Confederate officer, his sword drawn,

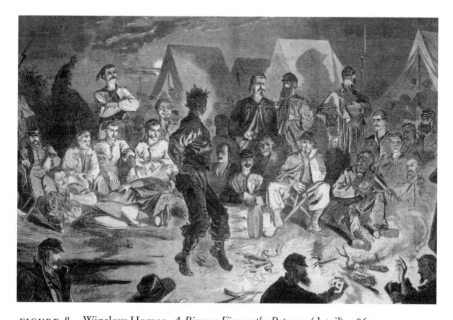

FIGURE 8 Winslow Homer, *A Bivouac Fire on the Potomac* (detail), 1861

From *Harper's Weekly,* December 21, 1861. 13¾ × 20¼ in. Collection of Duke University Museum of Art, Museum Purchase, Von Canon Fund (1974.2.64).

and black laborers forced to build earthworks and frightened by an exploding shell. But at the focal point he placed a dramatic black figure, upright and alert, with lightning flashing from his eyes (in the form of bayonets in the background), who sees the smoke from Union cannons in the distance and realizes that he and the other forced laborers may be killed in a bombardment by the very army seeking to liberate them from bondage.

Several years later, Homer executed a similar compelling picture about the dilemma of African American southerners hoping for freedom in the midst of war. This time the picture was in oil, and this time it focused on a black woman standing in the doorway of what could be a slave home or a plantation kitchen (plate 6). Her face is calm, but she grips her apron anxiously as she gazes off to the left-hand edge of the picture. Not far away, behind a low fence, a column of armed Confederates can be seen escorting unarmed Union soldiers. When this long-unknown picture was rediscovered in New Jersey in the 1960s and donated to the Newark Museum, senior Homer scholars initially brushed aside the military figures as of no real consequence; they argued that the artist had little interest in political events and gave the picture the innocuous title *At the Cabin Door*. Fortunately, a Civil War–era notice in New York's *Evening Post* later surfaced that revealed the true title of the work as recorded in an auction of Homer paintings on April 19, 1866. According to the paper, "his picture entitled 'Near Andersonville,' depicting a negro woman standing at the door of her cabin, gazing at Union prisoners as they pass, is full of significance."[9]

Significant indeed. It is one of the first American paintings to focus in a dignified way on an African American woman, and the title conveys the pathos of her situation. Andersonville was the grim stockade erected in southwest Georgia to hold captured Union soldiers, and the horrendous conditions there—with deaths reaching several hundred a day in the hot summer of 1864—had made the prison a topic of anguished discussion in the North. As the Union Army approached Atlanta, General William T. Sherman detached a division

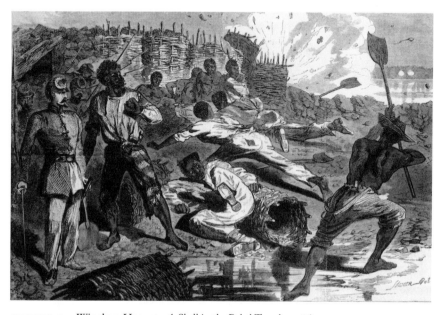

FIGURE 9 Winslow Homer, *A Shell in the Rebel Trenches*, 1863

From *Harper's Weekly,* January 17, 1863. 9¼ × 13⅞ in. Collection of Duke University Museum of Art, Museum Purchase, Von Canon Fund (1974.2.78).

to ride south and attack those guarding the camp. But the maneuver failed; the men who set out to liberate Andersonville were captured and became prisoners there themselves. Homer could have portrayed this reversal from the perspective of the white combatants; instead he elected to put the military figures in the background, inviting the viewer to contemplate the situation from the vantage point of a black woman. She remains enslaved, despite the nearby presence of a potential army of liberation, and we share her mixed emotions of anticipation and disappointment.[10]

Having portrayed blacks in meaningful ways during the Civil War, Homer continued to revisit this theme during the Reconstruction years. He repeatedly used the figure of an adolescent black youth to invoke the problems and possibilities facing African American exslaves in the promising post-emancipation era. Take, for example, *Weaning the Calf,* the intriguing oil at the North Carolina Museum of Art in which a black youth leads a calf away from its mother under the skeptical gaze of two white boys. Or *A Sunflower for Teacher,* the evocative watercolor of a shy African American boy anxious to begin his schooling, which is in the collection of the Georgia Museum of Art in Athens. Dalton and I have argued in some detail that these seemingly innocuous paintings can also be read as brooding comments on the Reconstruction era in which they were created. The same holds true for other important Homer pictures from the 1870s such as *The Busy Bee, The Watermelon Boys, Two Boys in a Cart,* and *Blossom Time in Virginia.*

As the last title suggests, Homer conceived a number of these works on a return visit to Petersburg, Virginia, in 1876.[11] *Sunday Morning in Virginia,* for example, depicts an old black woman who sits lost in thought while four children beside her pore over an open Bible. Living under slavery, the aging grandmother was never allowed to learn to read so that she could examine the Scriptures for herself. Now a new generation, represented by two boys and two girls of

different ages, finally has legal access to literacy and all the mysteries and advantages it presents.

Several of the major oil paintings that derive from Homer's Virginia trip—including *A Visit from the Old Mistress* and the impressive *Dressing for the Carnival*—contain substantial African American women. Scholars have often pointed out that the artist began to paint strong and independent women after his trip to northern England in 1881–82. During that twenty-month visit he did indeed sketch robust fisherwomen with their nets and baskets at Cullercoats on the North Sea.[12] But the rediscovery of *Near Andersonville* and another visit to the Virginia pictures should serve to remind commentators that Homer's images of powerful white females, first drawn near Tynemouth in England, were preceded by paintings that show forceful and strongminded black women in the American South. The most dramatic example, perhaps, is *Cotton Pickers,* the famous oil of two pensive African American women in a cotton field, which hangs in the Los Angeles County Museum.

Homer's career underwent marked changes in the early 1880s.[13] The shift was so significant that the works on either side of this watershed can sometimes be made "to seem like the creations of two entirely different men."[14] But substantial continuities exist, and one of the least explored is the fact that the artist did not abandon his depiction of black figures. He had mastered the technical challenges of portraying dark-skinned individuals realistically, and he found new ways to foster this interest at a time when many white writers and artists were producing increasingly crude and unflattering stereotypes of African Americans.[15] Homer returned to black subjects again— this time surrounded by water—when he visited Florida, Nassau, and Cuba over the course of several decades. Beginning in 1885, he traveled south on numerous occasions, enjoying the warm air, the clear light, and the dramatically different scenery, weather, and people. He painted mostly in watercolors, as in *West Indian Divers, Rum Cay, The Turtle Pound, The Water Fan, The Sponge Diver,* and *Fishing Boats, Key West.*

But he also created several oils with southern settings, and one of them, *The Gulf Stream,* again had a black figure at its center.

The central figure in *The Gulf Stream* (see frontispiece) made many contemporary viewers anxious. The unusual focus on a black man trapped in a powerful dilemma, rather than facing some simple or humorous problem, threw many white critics off balance. One expert spoke dismissively of the "sullen laziness" of the mariner; another saw him as "waiting apathetically." The art critic of the *Indianapolis News* wondered why the deck was not wetter and how the sailor kept himself from slipping off the listing hulk.[16] Prospective buyers pressed Homer's New York dealer, Roland Knoedler, for more details from the painter. In 1902, Homer responded to his dealer's inquiry with the best deadpan irony of a taciturn Yankee: "You ask for a full description of my picture of the 'Gulf Stream.' I regret very much that I have painted a picture that requires any description. The subject of this picture is comprised in *its title* & I will refer these inquisitive schoolma'ams to Lieut. Maury."[17]

Homer was referring to Matthew Fontaine Maury, the father of American oceanography, whom he had admired for years.[18] Nineteenth-century mariners venerated Maury for his oceanic charts and other practical contributions to navigation. His greatest work, *The Physical Geography of the Sea,* went through eight editions, in part because the eminent Virginia-born scientist had a compelling way of describing the globe's most elemental forces. In 1844, he had written an important study of the Gulf Stream, which he continued to refine, and his poetic observations on the topic—especially the powerful opening lines—were well known to many in Homer's generation:

> There is a river in the ocean: in the severest droughts it never fails, and in the mightiest floods it never overflows. Its banks and its bottom are of cold water, while its current is of warm; the Gulf of Mexico is its fountain, and its mouth is in the Arctic Seas. It is the Gulf Stream.

There is in the world no other such majestic flow of waters. Its current is more rapid than the Mississippi or the Amazon, and its volume more than a thousand times greater. Its waters, as far out from the Gulf as the Carolina coasts, are of an indigo blue. They are so distinctly marked that their line of junction with the common sea-water may be traced by the eye.[19]

Homer was familiar with Lieutenant Maury's forty-page discourse on the Gulf Stream, and he had observed the phenomenon repeatedly himself.[20] As the artist reminded Knoedler in his caustic letter of 1902, "I have crossed the Gulf Stream *ten* times & I should know something about it." The painter went on to brush aside sardonically the central elements of the picture that troubled numerous viewers. "The boat & sharks are outside matters; matters of very little consequence. *They have been blown out to sea by a hurricane.* You can tell these ladies that the unfortunate negro who now is so dazed & parboiled, will be rescued & returned to his friends and home, & ever after live happily."[21]

At least one critic has taken Homer's mocking description of *The Gulf Stream* at face value, claiming that this passage suggests Homer "quite frankly didn't give a damn what happened to the dazed and parboiled man."[22] It now seems quite clear, however, that Homer did indeed give a damn about this Negro, and about blacks more generally. I believe that an understanding of where his enduring sympathies lay opens up an obvious but unrecognized interpretation of this painting. At one level, the picture concerns events going on around Homer and filling the newspapers in the years between 1898 and 1900, the year he finished revising the painting for the last time. Various suggestive elements of the picture, arrayed around the central figure, lend weight to this interpretation, which is at odds with almost everything that has been written about the picture.[23] The implications linked to some of the elements are worth exploring in detail, beginning with the storm on the horizon.

* * *

We know from the writing across the stern that we are looking at the *Anna* out of Key West, so the sailor is an American drifting, presumably, in the Florida Straits. That means that the island of Cuba, the "Pearl of the Antilles," lies somewhere just below the southern horizon. A light streak on the horizon, added when Homer retouched the picture, suggests the edge of the Gulf Stream itself and the presence of land beyond. It is worth remembering that while the present generation has been sensitized to images of small boats coming *from* Cuba, Americans a century ago were acutely aware of boats going *toward* Cuba.

In 1898, Stephen Crane published "The Open Boat," which dramatized his own experience, as the featured piece in his collection entitled *Open Boat and Other Tales of Adventure.* On the last day of 1896, the popular young writer (whose Civil War tale, *The Red Badge of Courage,* had gone through fourteen printings that year) set out from Florida for Cuba aboard the *Commodore,* a vessel carrying a filibustering party to take part in the Cuban insurrection against Spain. When the ship struck a shoal, took on water, and sank, Crane found himself perilously adrift in a dinghy in the waters where the Gulf Stream skirts the coast of southern Florida. He eventually made it ashore, and he later found many readers for his account, partly because, as Crane's biographer points out, "Cuba was now the storm center of the Western Hemisphere."[24]

Could the swirling waterspout in the background of Homer's picture be related, consciously or subconsciously, to this storm centered over Cuba? Perhaps, for the conflict was on the minds of all Americans at the end of the century. Yellow journalism had dramatized the 1898 sinking of the battleship *Maine* in Havana Harbor. The press was full of cartoons whipping up a jingoistic frenzy urging America to declare war on Spain and help the supposedly bumbling Cubans to win their liberation. Uncle Sam always appeared in these cartoons as elderly, white, knowledgeable, and benign. Cuba, in contrast, always the troublesome Spanish colony, was often represented in the familiar

and grotesque pickaninny iconography of the time as a small, black, ignorant child.[25]

In the state of Maine, anguish over the sinking of the *Maine* was naturally strong (though in retrospect the evidence suggests that a design flaw, not Spanish sabotage, caused the costly explosion). At Prout's Neck, Homer drew some cartoons of his own seeming to parody the war fever. His aged father, only months before his death, had been one of the many who became wrought up over the issue and worried as to the whereabouts of the Spanish fleet.[26] "The Portland papers say that there will be a battery put on Prout's Neck, M[ain]e," Homer wrote in mock alarm at the bottom of one sketch (fig. 10). Later, he would paint a powerful and enigmatic picture, *Search Light on Harbor Entrance, Santiago de Cuba,* that offers a brooding reflection on the Spanish-American War.

The conflict itself in the summer of 1898 proved short and one-sided, lasting just long enough for Theodore Roosevelt to enhance his reputation at the head of the Rough Riders. Writing from England to compliment him, a friend observed that it had been "a splendid little war." The congratulatory phrase caught hold, and for generations Americans used the jaunty term to refer to the conflict in Cuba.

Almost forgotten now is the complicated factor of African American troops' participation in the war, but it was a controversial issue in the spring of 1898. Whites were divided on the issue of deploying Negro troops, and African Americans were split as well. "I will not go to war," a black man wrote to an Iowa newspaper. "I have no country to fight for. I have not been given my rights." On the other hand, a correspondent for the *Freeman,* an African American newspaper in Indianapolis, argued that the coming war could prove to be "a blessing in disguise for the Negro." The black soldier, he predicted optimistically, will be well trained, well paid, and "will have an opportunity of proving to the world his real bravery, worth and manhood." Besides, if nothing else, he will "be possessed of arms, which in the South in the face of threatened mob violence he is not allowed to have."[27]

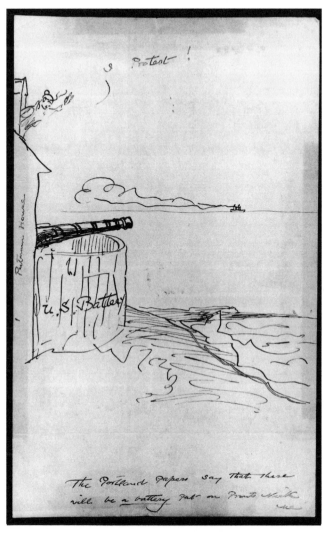

FIGURE 10 Winslow Homer, *I Protest! / Putnam House / The Portland papers say that there will be a battery put on Prout's Neck, Me,* 1898

Ink on paper, 8⅞ × 5⁹⁄₁₆ in. (22.54 × 14.13 cm). Bowdoin College Museum of Art, Brunswick, Maine. Gift of the Homer family (1964.69.82).

The uniformed black soldiers sent to mobilization centers in Georgia and Florida were indeed armed, and their presence aroused immediate resentment among white inhabitants. In Key West, one of the first gathering points, local authorities arrested a black infantryman on dubious charges in order to send a message of racial control. But other soldiers in his unit saw to it that he was quickly released, and news of the incident appeared in papers, fanning tensions.[28] At Lakeland, Florida, near Tampa, violence broke out soon after the arrival of the Tenth Cavalry when a member of the all-black unit, wearing his U.S. Army uniform, was denied service at a white-owned soda fountain. Irate black soldiers descended on the drugstore, pistol-whipped the proprietor, and confronted the hostile mob that assembled outside. Angry words, then shots, were exchanged. When a white antagonist died from a stray bullet, authorities arrested two black soldiers and disarmed the rest of the Tenth Cavalry.[29]

The largest contingent of black troops—several thousand men composing the Twenty-fourth and Twenty-fifth Infantry Units and the Ninth Cavalry—encamped in Tampa, where race antagonism heated up rapidly and finally boiled over. One expert on the affair summarizes the confrontation in Tampa as follows:

> On the eve of the army's embarkation for Cuba, the tension there erupted in the most serious racial clash that occurred in a military encampment during the Spanish-American War. Triggered by drunken white volunteers from an Ohio regiment who used a Negro child as a target to demonstrate their marksmanship, the Tampa riot lasted through the night of June 6, 1898, and was not finally quelled until the following morning. Despite military censorship, dispatches from Tampa claimed that the streets of the city "ran red with negro blood." At least twenty-seven Negro soldiers and three white volunteers were so seriously wounded that they had to be transferred to a military hospital near Atlanta.[30]

The African American troops who landed in Cuba took part in significant battles and accounted well for themselves under fire. The Twenty-fourth and Twenty-fifth Colored Infantries helped to rescue Roosevelt's Rough Riders at San Juan Hill, but their accomplishments were downplayed. On their return to the United States, in fact, black units were obliged to march at the back of segregated victory celebrations. African American soldiers had been astonished to find that the majority of the Cuban freedom fighters were black, especially since black officers were almost totally absent in the American ranks. Many actually returned to Cuba, drawn by the independence struggle of a nonwhite majority that they had viewed firsthand. Homer had been to Cuba himself, and he had been conscious of discrimination issues for years, so his juxtaposition of a strong black man with a spiraling storm over Cuba should not be surprising.

For African Americans, most of whom still lived in the South, there were storm clouds and tornadoes closer to home as well.[31] In the United States, resurgent Klan violence and increased lynchings were battering the black community. In North Carolina, the situation at first appeared promising for blacks; a coalition (or "fusion") of Populists and Republicans had managed to defeat "Redeemer" Democrats in 1894 and take control of the state legislature. Soon, several hundred black magistrates had been elected by "fusionists" in the eastern part of the state, where black voting was strong. In Wilmington, on the North Carolina coast, a black port inspector was appointed, and fourteen African Americans served on the local police force.[32]

But the backlash was swift, spurred on by racist articles and cartoons in white-owned North Carolina newspapers. It came to a head in the notorious election of 1898 when white militia units intimidated voters and brought down the fusionist government. Senator "Pitchfork Ben" Tillman of South Carolina journeyed north to throw

his weight into the campaign for North Carolina's Democrats, waving "the banner of white supremacy" and urging voters, "Rally to your colors. Be a white man or be a nigger. You have got to take your choice."[33] The demagoguery of these "Red Shirts" brought the Democrats to power in November 1898.

Democrats failed to win local elections in eastern North Carolina, however, where the large black population refused to be intimidated. Not to be foiled, the antiblack forces resorted to violence where they could not succeed at the ballot box. In the port of Wilmington they were urged on by an ex-congressman named Alfred M. Waddell. The national press reported an inflammatory speech by Colonel Waddell in which he demanded a change of the city's government by any means—even "if we have to choke the current of the Cape Fear River with carcasses."[34] Two days after the fall election, vigilantes in the state's largest town "destroyed a black newspaper whose editor had challenged white-supremacist rhetoric about black sexuality, murdered at least a dozen black men, and seized the city government. This coup d'état" in Wilmington, asserts Tillman's biographer, "brought down the last major redoubt of bi-racial Southern politics."[35] Moreover, it was followed within days by a similar violent riot at Phoenix, in Tillman's own state of South Carolina.[36]

The stormy riots at Wilmington and Phoenix were in fact murderous coups by powerful white vigilantes to seize political control illegally, and they were well publicized in the national press. Homer had shown over the years that he was not unaware of such matters, and the violent incidents may well have figured—even if only subconsciously—in his formulation of *The Gulf Stream*. After all, the notorious 1876 South Carolina episode known as the Hamburg Massacre had helped to shape his earlier picture, *Dressing for the Carnival*.[37]

When the black writer Charles W. Chesnutt framed his North Carolina novel, *The Marrow of Tradition* (1901), he repeatedly used storm imagery to describe the violence in Wellington, his fictional equivalent to Wilmington. In a chapter called "Mutterings of the Storm,"

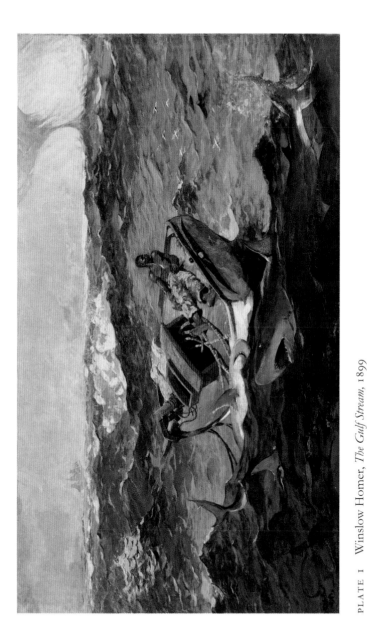

PLATE 1 Winslow Homer, *The Gulf Stream*, 1899

Oil on canvas, 28⅛ × 49⅛ in. (71.4 × 124.8 cm). The Metropolitan Museum of Art,
Catharine Lorillard Wolfe Collection, Wolfe Fund, 1906 (06.1234). Photograph © 1995 The
Metropolitan Museum of Art. All rights reserved, The Metropolitan Museum of Art.

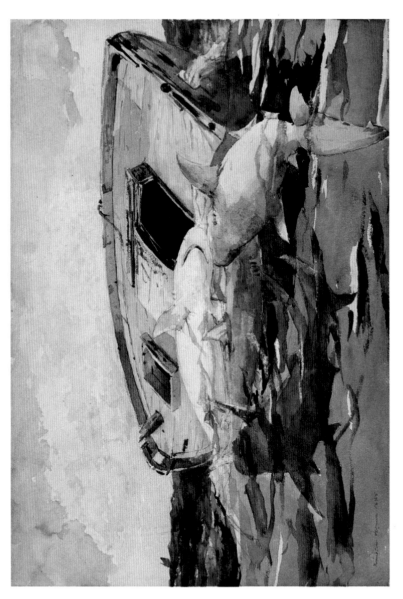

PLATE 2 Winslow Homer, *Sharks*, also called *The Derelict*, 1885

Watercolor over pencil, 14½ × 20¹⁵⁄₁₆ in. (36.9 × 53.2 cm). The Brooklyn Museum of Art Bequest of Helen B. Sanders (78.151.4).

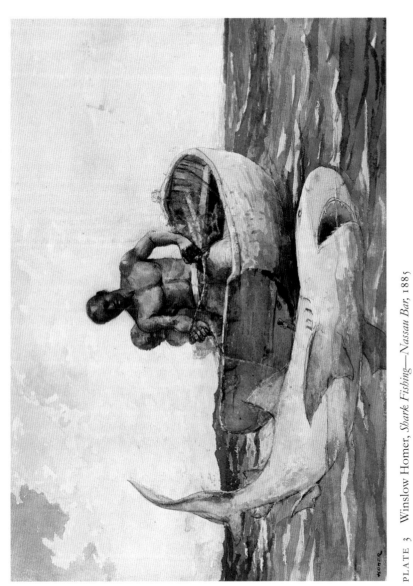

PLATE 3 Winslow Homer, *Shark Fishing—Nassau Bar*, 1885

Watercolor, 13⅝ × 20 in. (34.6 × 50.8 cm). Private collection.

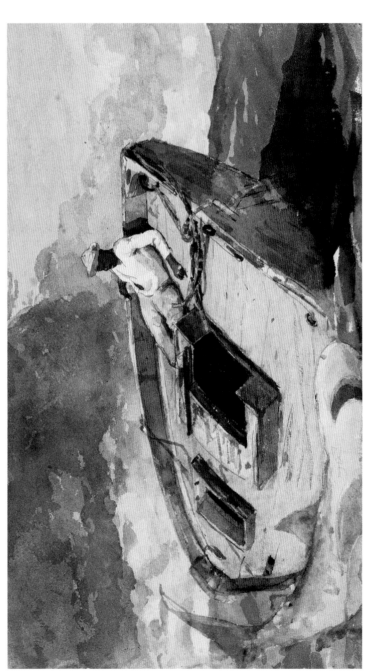

PLATE 4 Winslow Homer, *The Gulf Stream*, 1889

Watercolor, 11⅜ × 20¹⁵⁄₁₆ in. (28.9 × 51 cm). The Art Institute of Chicago, Mr. and Mrs.
Martin A. Ryerson Collection (1933.1241). Reproduction, The Art Institute of Chicago.

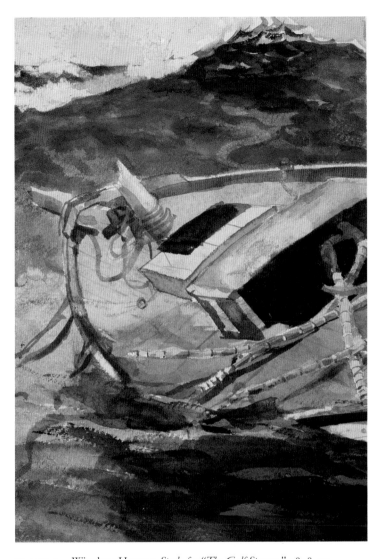

PLATE 5 Winslow Homer, *Study for "The Gulf Stream,"* 1898–99

Brush and watercolor; black chalk on off-white heavy wove paper; 14$\frac{1}{2}$ × 10$\frac{1}{16}$ in. (368 × 256 mm). Cooper-Hewitt, National Design Museum, Smithsonian Institution. Gift of Charles Savage Homer Jr. (1912-12-36). Photograph: Ken Pelka.

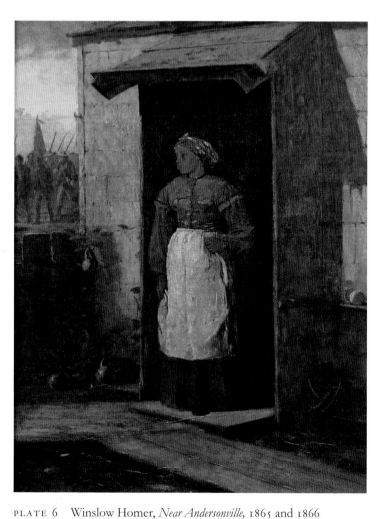

PLATE 6 Winslow Homer, *Near Andersonville,* 1865 and 1866

Oil on canvas, 22 × 17¼ in. (55.9 × 43.8 cm). Collection of the Newark Museum, New Jersey. Gift of Mrs. Hannah Corbin Carter, Horace K. Corbin Jr., Robert S. Corbin, William D. Corbin, and Mrs. Clementine Corbin Day in memory of their parents, Hannah Stockton Corbin and Horace Kellogg Corbin (66.354). Photograph © The Newark Museum.

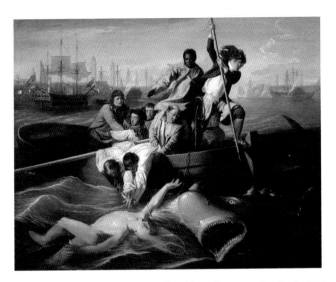

PLATE 7 John Singleton Copley (American, 1738–1815), *Watson and the Shark,* 1778

Oil on canvas, 72¼ × 90⅜ in. (183.5 × 229.6 cm). Museum of Fine Arts, Boston, Gift of Mrs. George von Lengerke Meyer (89.481). Photograph © 2003 Museum of Fine Arts, Boston.

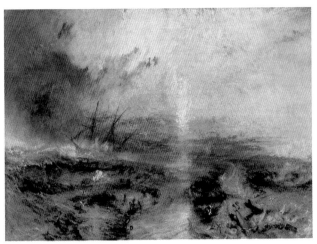

PLATE 8 J. M. W. Turner (English, 1775–1851), *Slave Ship (Slavers Throwing Overboard the Dead and Dying, Typhon Coming On),* 1840

Oil on canvas, 35¾ × 48¼ in. (90.8 × 122.6 cm). Museum of Fine Arts, Boston, Henry Lillie Pierce Fund (99.22). Photograph © 2003 Museum of Fine Arts, Boston.

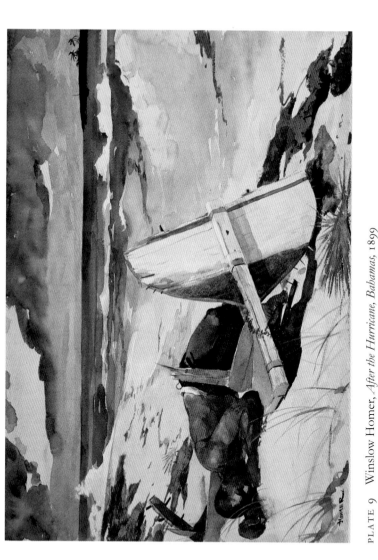

PLATE 9 Winslow Homer, *After the Hurricane, Bahamas*, 1899

Watercolor with touches of reddish-brown gouache and with traces of scraping
over graphite, on off-white wove paper; 15 × 21 3/16 in. (38.1 × 54.3 cm). The Art
Institute of Chicago, Mr. and Mrs. Martin A. Ryerson Collection (1933.1235).

Chesnutt wrote that blacks "became alarmed at the murmurings of the whites, which seemed to presage a coming storm." He titled his climactic chapter "The Storm Breaks."[38]

At the heart of this storm was black disenfranchisement. In 1890, sensing a diminished national commitment to the rights of African Americans, the white minority in Mississippi rewrote the state's constitution. They hoped to circumvent the Fifteenth Amendment, ratified in 1870 to ensure that the right of citizens "to vote shall not be denied or abridged by the United States or by any State on account of race, color, or previous conditions of servitude." The new state constitution did not mention race at all, but it contained a potent "understanding clause" stating that all voters must be able to read and interpret any portion of the state's constitution to the satisfaction of local election officials. The U.S. Supreme Court upheld the legality of this clause in 1898 in the case of *Williams* v. *Mississippi*.

Historian Willard Gatewood observes: "Beginning with the 'massacre' at Wilmington, North Carolina, and the mine wars in Illinois in the fall of 1898, reports of racial incidents appeared in the press almost daily for the next two years, culminating in the bloody race riots in New Orleans, Akron, and New York in the summer of 1900." He notes that by early 1899 numerous black leaders believed "that the condition of Negroes in the South had become so bad that their survival seemed to depend upon a foreign power taking up the cause of humanity in their behalf." Negro leaders meeting in Ohio "passed a resolution imploring foreign governments to protect black Americans from lynchers."[39]

Another symbol that epitomizes this crisis even more vividly than the storm is the rope. The noose had become a potent emblem of threat and intimidation. Rope shown, as it is in *The Gulf Stream,* in close relation to a strong but disempowered black man evoked a particular meaning at the end of the nineteenth century. Walter White's pioneering study of lynching, for example, published in 1928, is entitled *Rope and Faggot*. In it, White points out that in the twenty-one years

from 1882 to 1903, some 3,337 persons were lynched in the United States.[40] That staggering figure eventually gave rise to a determined antilynching movement and made a lasting impact on the aspirations, beliefs, and music of a generation of black southerners.[41] Most of the murders occurred in the South, most victimized African American men, and most involved ropes. Ropes are visible aboard the *Anna,* including those hanging from the bow, but also the one grasped in the mariner's left hand and perhaps girdling his waist. If he somehow secured himself with the short line running through the pulley beside him, then in this case a rope may have saved a black man's life. But more often the opposite was true.

Events in Georgia during the spring of 1899 bear that out. The region became a battleground in what writer James Weldon Johnson, an 1894 graduate of Atlanta University, called "the tremendous struggle which is going on between the races in the South."[42] On March 15, 1899, nine black men were arrested on charges of arson in the little town of Palmetto, Georgia, just southwest of Atlanta. Immediately, according to historians, "a masked mob rode into town, lined up the nine suspects, tied them together with ropes, and shot them, killing four (perhaps five)."[43] "As if the act itself was not enough," Georgia governor Allen D. Candler "placed the blame for the Palmetto crime upon the pernicious influence of black volunteers recently encamped in his state. The governor maintained that their presence had disturbed 'the peaceful race relations' existing in Georgia and produced tensions which were responsible for violent acts against blacks."[44]

Whites had opposed the presence of armed black troops in Georgia before and after the brief war in Cuba, and politicians like Governor Candler encouraged these resentments in ways that almost ensured further violence. Lynchings in Georgia occurred at a rate of more than two per month during Candler's administration. Moreover, for several years the flamboyant reformer-turned-racist Rebecca Felton had been exhorting the state's white citizens to protect their women from presumed black rapists by taking the law into their own

hands. The white residents of Palmetto, riled up by the extralegal shootings in March, pressed for another lynching in April when a twenty-one-year-old black laborer named Sam Hose was accused of killing his boss in an argument. On Saturday, April 23, they got their wish in the neighboring village of Newnan, the county seat for Coweta County. Hose never reached a jail cell, much less a courtroom. Instead, the local sheriff turned him over to an angry mob, which refused to hear the pleas of a moderate former governor that they allow the law "to take its course."[45]

The vigilantes marched Hose to a field along the Palmetto Road and gathered fence posts for a bonfire as a sea of several thousand onlookers assembled. A special excursion train brought spectators from Atlanta. The mob leaders stripped away the accused man's clothes and lashed him to a tree trunk. With no help in sight, the victim begged to be dispatched quickly; instead he was tortured slowly at knifepoint, losing his ears, his fingers, and his genitals before being doused in kerosene and burned alive. He died in utter agony, with his teeth embedded in a post.[46] Soon afterward, a black minister named Elijah Strickland who spoke up for the civil rights of Sam Hose literally risked his own neck and lost. So did Albert Sewell, a frustrated black Georgian who voiced his desire to see some form of retaliation for the killing of Hose. Lynch mobs hanged both men.[47]

Aware of the frequency of violent racial attacks in which African Americans were lashed to trees and stakes with lengths of rope, we can look more closely and with more understanding at the slack lines that coil around the broken mast near the bow of the *Anna*. Clearly, the storm has brought violence, and the flecks of blood in the water suggest that another black sailor may have recently lost his life at sea. The shattered stump of the mast, with its twisting ropes, is bracketed in the composition by the forward cleat, which forms a small wooden cross, and the crumpled white sail draped across the gunwale. Did the artist frame this passage with a conscious thought, or even a subliminal awareness, that stark crosses and eerie white sheets

were often present when a black southerner died on land, tied to a stake?

Another important element of the picture can be easily overlooked: the enormous breaking wave in the near distance, directly beyond the boat. Like the rope, it too appears near the center of the canvas, and it too has specific, and somewhat dated, connotations of racial violence. Clearly, the strange form serves several useful compositional roles. It echoes the larger triangle created by the remote ship, the typhoon, and the battered boat; and it provides a middle distance, linking the foreground to the horizon. The billowing foam, though contrasting in color, has almost the same horizontal shape as the ominous shark emerging in the darkened foreground, and the two elements together frame and enclose the boat within a wide trough, almost like the opposing jaws of a vise.

Homer, the experienced sea painter who lived next to the Atlantic at Prout's Neck, had observed breaking waves in all kinds of weather, and he had woven them forcefully into his seascapes again and again. However, unlike the very similar breakers in his magnificent 1895 coastal paintings, *Cannon Rock* and *Northeaster,* this singular wave in the open ocean seems unusually large and unexpected. It certainly suggests the Gulf Stream itself, where changing water temperatures and colliding winds and currents can produce choppy waves and patches of white water. It also conveys the fact that the sea remains disturbed after the recent sudden storm. [48] To a mariner's eye, the billowing froth might even suggest underwater danger close at hand, since waves passing over a hidden shoal or reef will crest and break. Whether caused by brisk winds, shearing currents, or shallow water, the breaking wave seems to form a visible barrier between the stranded man and the full-rigged ship sailing complacently in the distance.

Such cresting waves are commonly known as whitecaps, for obvious reasons. They often appear in shallow water close to shore or in clusters across a wide area at sea when wind and wave conditions are right. But if we are in the open ocean, as we seem to be, then why

is there a single large whitecap in the center of the picture? We need to consider the possibility that there may be some sort of subliminal suggestion here, something that goes beyond a purely oceanographic representation. If so, it is an allusion that we could hardly recognize or fathom in the early twenty-first century; but when deciphered, it takes on a significant relevance. Or perhaps it does not, for that always depends, in the last analysis, on the individual viewer. Just as works of art can be underinterpreted, they can also be overinterpreted. When examining layers of meaning, viewers always remain free to disagree over whether some supposed metaphorical symbol has been wittingly inserted, conjured unknowingly from the artist's subconscious, or simply imposed on the picture by an overzealous interpreter.

At the risk of such overinterpretation, let me raise a possibility regarding the looming whitecap. As I do so, keep in mind that Homer spent his formative artistic years working at *Harper's Weekly,* where he learned to insert visual puns and pointers into his pictures on a regular basis. Elsewhere, for example, Karen Dalton and I have discussed the artist's logic in placing a black figure in the foreground of a wartime wood engraving entitled *Pay-Day in the Army of the Potomac.* To modern viewers, the work at first seems an innocuous scene of rowdy soldiers descending on a busy storekeeper, jostling to spend their meager wages on the sutler's biscuits and cheese. But a contemporary seeing the picture would have immediately noticed the bearded sutler's resemblance to President Lincoln, a fact that generations of art historians have overlooked. The sutler's closeness to the black man, the presence of a set of scales between them, and the agitation of the surrounding Union soldiers all make greater sense when you realize that *Pay-Day* appeared in the issue of *Harper's Weekly* for February 28, 1863—just weeks after Lincoln's Emancipation Proclamation took effect.[49] When done well, as with the grocer's scales, such insertions can be read equally plausibly as appropriate, mundane details or as veiled references to broader issues.

The whitecap may well be just such a reference. In the marine context, the word *whitecap* refers to a breaking wave; but on land it once had another connotation. This dry-land meaning, specialized and dated, is associated with the late nineteenth century and with issues of race relations—facts that may bring it closer to the center of our picture. The term apparently originated in Indiana when night riders disguised in white caps terrorized black farmers to drive them off their land. The practice became most common in the rural South, where more than two hundred instances were recorded in the 1880s and 1890s.[50] Historian Stephen Kantrowitz explains that for white supremacists, even after they had successfully brought Reconstruction to an end in 1876,

> extralegal collective action was still essential. As Red-shirts, "white-caps," or lynchers, white men assaulted those who threatened white-supremacist political, economic, or social structures. . . . By the 1890s, lethal and nonlethal vigilante violence against African Americans had become a regular feature of Southern life. . . . Bands of armed white men broke up Republican and independent political meetings and black laborers' organizations, and groups known as "white-caps" policed interracial social and sexual boundaries.[51]

It was clear to African Americans that raw power, rather than any moral or political right, was being used to enforce these boundaries. The black poet and essayist Paul Laurence Dunbar encapsulated the violent mood in an essay entitled "Negro and White Man," which appeared in the *Chicago Record* on December 10, 1898. Cutting to the stark reality of the time, Dunbar summed up the attitude he saw coming from belligerent whites as follows: "We do not like you; we do not want you in certain places. Therefore, when we please, we will kill you. We are strong people, you are weak. What we choose to do we will do; right or no right." This aggressive stance, encouraged by numerous politicians, sanctioned "whitecapping," which had a particular focus. Whitecappers did not aim their acts of intimidation at the

poorest black southerners, but rather at families that showed signs of succeeding against the odds. The victims of scare tactics and violence were usually the most determined, capable, and hard-working members of the African American community, the sons and daughters of slaves who believed in their right to cast ballots, attend schools, own property, and ride on public transportation.

The question of public transport takes us beyond the whitecap to the three-masted ship on the horizon in *The Gulf Stream*. It could not pose a greater contrast to the *Anna,* which it clearly has not noticed. It is large and spacious, speeding along under full sail, and apparently it has not encountered foul weather on its voyage, though it seems to be heading toward a major squall. One way, among many, to describe its presence would be to say that we are seeing two utterly separate and unequal ships passing one another in stormy southern waters. Keep in mind that the 1890s was the decade in which the Supreme Court of the United States upheld the practice of racial segregation on trains and streetcars, and in other public places, justifying its decision in terms of the ambiguous doctrine of "separate but equal."

This phrase, which secured the strange career of Jim Crow for another two generations, emerged from the case of *Plessy* v. *Ferguson,* which reached the high court in 1896. After significant organizing by African Americans in Louisiana, a light-skinned black man named Homer Plessy had challenged the state's 1890 law segregating railroad cars and prohibiting anyone from entering "a coach or compartment to which by race he does not belong." Boarding a train in New Orleans, he had been forcibly removed from a whites-only car, even though he held a first-class ticket. Plessy, who was jailed for his offense, protested that the law compromised his Thirteenth and Fourteenth Amendment rights. But Justice Henry B. Brown disagreed. Speaking for the Supreme Court's eight-to-one majority, he argued that prejudices could not be "overcome by legislation."[52]

Justice Brown explained that if anyone thought "the enforced separation of the two races stamps the colored race with a badge of

inferiority," that was "solely because the colored race chooses to stamp that construction upon it." "If one race be inferior to the other socially," Brown concluded, "the Constitution of the United States cannot put them upon the same plane." Only Justice John Marshall Harlan, the son of a Kentucky slaveholder, issued a dissent. In one of the great opinions of American legal history, Harlan wrote, "Our Constitution is colorblind, and neither knows nor tolerates classes among citizens. In respect of civil rights, all citizens are equal before the law."[53]

In February 1899, the same month that the Spanish-American War came to a formal end,[54] *McClure's Magazine* published Rudyard Kipling's famous poem entitled "The White Man's Burden," with its references to

> Your new-caught sullen peoples,
> Half devil and half child.

The poem was ambiguous about the costs of empire, but the title caught the imagination of Americans, in the wake of their first imperial war, and scores of articles and editorials blossomed across the United States in the following months.[55] In March, a black newspaper in Louisiana (where the *Plessy* case had originated) editorialized regarding the so-called white man's burden. Tired of hearing laments about black incompetence, shiftlessness, and social inferiority, the *Southwestern Christian Advocate* in New Orleans turned the proposition on its head. The real truth, the editor wrote, is that,

> in this country the white man considers that Negro [to be] the burden who wants to be somebody. For his benefit state constitutions are recast and separate car laws enacted. For him white-cap notices are posted and bands of armed men ride at dead of night. He is counted "too smart" when he contends for his rights, and in many communities ordered to leave his property or crop when he seems too prosperous. This is "the white man's burden."[56]

This image of black southerners forcing their way upward only to be pushed back down brings us to an additional element in *The Gulf Stream*. This facet is easily missed in a first or second glance at the picture, but it deserves more attention than it usually receives. Near the right-hand edge of the painting, a scarcely visible school of flying fish rises from the blood-streaked ocean. The translucent and ethereal fish appear off the starboard side of the *Anna,* almost as if they have been frightened from the water by the churning sharks or by the collapse of the mast, which smashed part of the starboard gunwale when it toppled into the sea. They skim above the water like so many souls ascending to heaven. More than the sailing ship and the waterspout in the distance, or the circling sharks in the foreground, they appear to occupy at least some portion of the lonely seaman's gaze. He stares toward and through and beyond this school of flying fish.

To a nonsailor, the delicate flying fish, if noticed at all, might seem an emblem of transcendence and hope. But those who have spent time on the ocean—including Homer himself and the black boatman he depicted—have a fuller and darker understanding of these unique creatures and their unusual plight. Repeated observation and traditional lore told mariners that the plight of these unusual fishes is hopeless indeed. Swimming in the sea, flying fish can be chased and eaten by sharks and other predators. (In *The Gulf Stream* they seem to be fleeing the thrashing sharks like a covey of quail flushed upward by a bird dog.) For protection, a flying fish can propel itself into the air with a thrust of its strong tail and then, without actually flying, glide through the air on its winglike pectoral fins. But when they burst from the water and sail briefly above the surface, flying fish are far less free and safe than they appear. Predatory sea birds swoop down to devour them, or they may land helpless on a boat's deck, to be eaten by the crew.

Travelers in semitropical waters saw flying fish often and examined them closely when they fell on deck. One of many who recorded

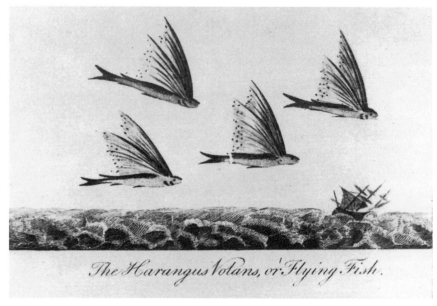

The Harangus Volans, or Flying Fish.

FIGURE 11 John Gabriel Stedman, *Flying Fish,* 1791

From John Gabriel Stedman, *Narrative of a Five Years Expedition against the Revolted Negroes of Surinam* (London, 1796). Image engraved and published by Joseph Johnson, December 1, 1791, St. Paul's Church Yard, London.

such an experience was John Gabriel Stedman, a young soldier who crossed Atlantic waters in 1773 as part of a corps sent to Dutch Surinam in South America to help suppress a revolt by escaped African slaves (fig. 11). In his popular illustrated *Narrative,* which went through twenty editions in half a dozen languages, Steadman recalled that "numbers of *flying fish*" became caught in the ship's shrouds during the long ocean passage. This species, he wrote, "is about the Size of a Herring . . . the Sides and Belly of a resplendent Silvery white . . . and the Scales hard, Smooth and Silvery." Stedman concluded that the flying fish "is both the prey of the Scaly, and the feather'd Creation—and that it often meets his doom in that Element to where it made application for its Safety."[57] Drawing on his own experience and his talks with seasoned sailors, Stedman quickly came to understand that mariners viewed this aquatic species as the epitome of all those obliged to live constantly between the devil and the deep blue sea. At the end of the next century, Homer would subtly link flying fish with African American southerners, who found themselves caught perpetually in that situation, not knowing where to turn for support or succor during troubled times.

Though Homer understood the awesome scope and endless fascination of the Gulf Stream, the current itself certainly does not constitute the entire subject of his canvas. Lieutenant Maury aside, the full force of *The Gulf Stream* comprises significantly more than its title. Part of its power can be gleaned from an examination of the picture's contemporary context in the 1890s, which we have sketched here but by no means exhausted. We have looked toward Cuba and the stormy horizon; we have skirted the coast of the Southeast from Wilmington to Tampa, and we have moved inland as far as central Georgia. In the next chapter, we shall dive deeper into the wreck. Instead of looking at the historical present, we shall plunge further downward and back

in time, into even darker waters—into our collective past as a people. In the shark-infested, blood-flecked waters of the great current, we may find the deepest, most enduring level of meaning for Homer's painting and the most compelling reasons for its continuing hold on our national psyche.

The Past Looking Back toward Slavery

In many ways, the person closest to Winslow Homer while he was painting *The Gulf Stream* was a black man, an ex-slave from Virginia named Lewis Wright, who had moved to Maine in 1896 to serve as the personal servant for Homer's aging father, Charles Homer. Before that, Wright had been employed as a waiter in the dining room at the American House in Boston, where Charles Homer usually spent the winter months. Since the painter had also used the American House as his base during many stays in Boston, the Homers must have had considerable familiarity with Wright. Winslow Homer visited his father several times during the winter of 1895–96, spending Christmas with him at the American House and worrying about his eating habits. "Father & self have had a very pleasant Christmas," Winslow wrote on December 25 to his sister-in-law. "I shall go home tomorrow. . . . We get as much alike as two peas—in age & manners—He is very well—only he will starve himself—I shall go to Boston once in two weeks this next month to give him a dinner."[1]

Both of the artist's brothers were married, and it fell to the bachelor Winslow to take the largest share of responsibility for looking after their elderly parent, who could be troublesome and demanding. At about this time, when Charles senior developed a case of intestinal flu, "the Homer brothers induced Lewis" to come to Maine for the summers and assist their octogenarian father. Winslow, who turned

sixty in February 1896, needed some help with his parent, and he would have been favorably disposed toward anyone who could treat the old man well and put up with his gruff manner and frequent demands. Wright and his wife were virtually the only African Americans in Prout's Neck, and Lewis quickly grew to be a local fixture, "living out but helping with cleaning and chores" while "appearing to take unlimited pleasure in waiting on Father Homer hand and foot." In a lengthy and ceremonious nightly ritual, he even brushed the vain old man's "long flaxen locks," gently rubbed oil into his scalp, and then helped him into bed. The elder Homer called him "Luke," but white servants in the vicinity addressed him as Mr. Wright "because of his dignity, good disposition, and impeccable manners. . . . He soon became quite a personage and was liked and respected by everyone."[2]

The famous painter seems to have been particularly appreciative of Wright (fig. 12). In appearance the black Virginian, despite his very different background, was not unlike Homer himself—slender, erect, balding, and mustached—and in age he was probably within a few years of Homer. Philip Beam, whose book *Winslow Homer at Prout's Neck* is based on extensive family interviews and recollections, comments that Winslow "grew very fond of Lewis, as did the other members of the Homer family."[3] According to Beam,

> During the previous ten years Winslow had taken great care of his father, but little by little Lewis took much of the burden on himself and freed the painter for his work. The two enjoyed constant jokes together; as Lewis grew older Winslow used to accuse him of using shoe blacking on his graying hair. A photograph in the Homer Collection taken outside of the studio shows the two men smiling at each other with unfeigned affection.[4]

For Wright and his wife, the position offered by the Homers must have been an excellent opportunity, given the options available to blacks at the turn of the century, even if it meant leaving the black community in Boston for long stretches. Though little is known of

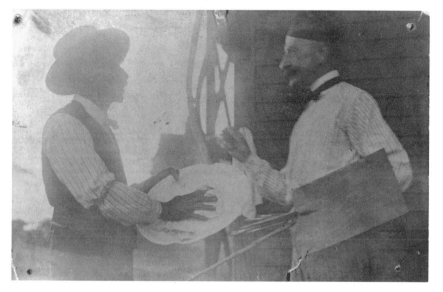

FIGURE 12 Lewis Wright (the Homers' servant) and Homer outside the studio, 1898–99?

Photograph. Bowdoin College Museum of Art, Brunswick, Maine. Gift of the Homer family.

their lives, the Wrights clearly brought their own strong aspirations and grievous losses with them. Beam recounts that the ex-slave "was able to send his son to Tuskegee Institute," the pioneering black school founded by Booker T. Washington in Alabama in 1881, but to Mr. Wright's "great grief, the boy was accidentally killed the year he was to have graduated."[5]

With the death of Homer's father in 1898, Wright and Homer may have drawn even closer together. Wright's responsibilities turned more toward looking out for the painter; according to Beam, he "gladly assisted the artist, to whom he was devoted, in various ways."[6] Homer, who had spent considerable time with his parent, no doubt appreciated the presence of someone who had known, humored, and appreciated the gruff old man. Lewis made sure that Winslow was undisturbed while he worked at his easel, and long after the artist's death he still enjoyed greeting visitors. On Saturday afternoons the studio would be opened to admiring summer tourists, "and he took great satisfaction in the homage paid to the memory of his departed friend."[7]

Whether or not Lewis Wright had any influence on the creation of *The Gulf Stream* is not known. But it seems plausible that the presence of the ex-slave from Virginia played a role in prompting Homer to reminisce openly or to think back consciously (or perhaps simply to return subconsciously) to his own encounters with the issue of racial enslavement. *Harper's Weekly* had given ample coverage to the dramatic efforts of slaves to escape to freedom during the early days of the Civil War, and when the journal assigned the young artist to be a correspondent with the Army of the Potomac in Virginia, he had seen numerous ex-slaves, known as "contrabands," in the Union camps. In a graphic spread for *Harper's* entitled *The Songs of the War,* he illustrated the popular tune "Dixie" with a picture of a black man seated on a powder keg labeled "Contraband" (fig. 13). He certainly understood

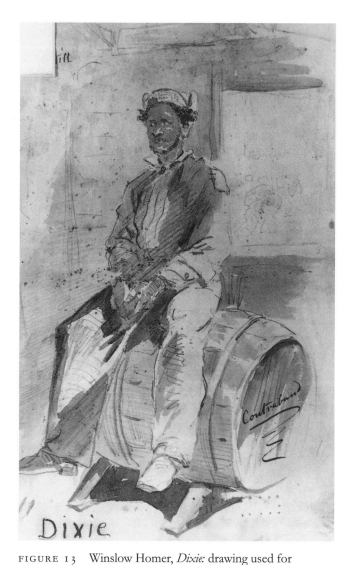

FIGURE 13 Winslow Homer, *Dixie:* drawing used for
The Songs of War in *Harper's Weekly,* November 23, 1861

Brush and gray and brown wash on cream paper, 9¹⁵⁄₁₆ × 6¾ in. (251 ×
170 mm). Cooper-Hewitt, National Design Museum, Smithsonian
Institution. Gift of Charles Savage Homer Jr. (1912-12-120).

the high costs for enslaved blacks of risking escape and the political explosiveness of the contraband issue.[8]

But Homer's personal awareness of slavery issues stretched back much further into his childhood. After all, before the Civil War the nation had never been without legally sanctioned race slavery. The open importation of Africans had ended in 1808, nearly three decades before Homer's birth. But the practice of slavery continued, and slave labor camps dotted the southern landscape, turning the region into an enormous gulag. Harriet Beecher Stowe dramatized the plight of slaves for a generation of readers with the publication of *Uncle Tom's Cabin* in 1852, when Homer was sixteen. Moreover, illegal vestiges of the Atlantic slave trade continued, and occasional incidents made headlines.

As a small boy, for instance, Homer undoubtedly heard talk that followed the famous *Amistad* case, when slaves being sent to Spanish Cuba mutinied under the leadership of a man named Joseph Cinqué and ended up in New Haven, Connecticut, in 1839. One of those who took up their cause was John Quincy Adams, then serving as a member of Congress from eastern Massachusetts. The elderly former president argued the Africans' case before the Supreme Court, successfully defending their right to seek liberty and justifying their action in killing those who had enslaved them. The trial, and then the return to Africa of Cinqué and his followers in 1842, received extensive publicity, especially in New England.[9]

The Homer family was living in Cambridge in 1851 when the black man Thomas Simms became the first person in the area forcefully returned to slavery through the new Fugitive Slave Act. Three years later, Boston abolitionists made strong efforts to oppose the return of escaped slave Anthony Burns to bondage in Virginia. In both instances, broadsides announcing protest meetings appeared in Boston and Cambridge, and there was widespread discussion of the dramatic events.[10] Thomas Wentworth Higginson, a prominent leader of the

antislavery resistance on both occasions, lived only a short walk from the Homer residence.

In 1856, Representative Preston Brooks attacked Senator Charles Sumner on the floor of the U.S. Senate and beat him senseless with a cane. The caning of the prominent antislavery senator from Massachusetts by the irate representative from South Carolina stirred deep passions. Homer, still serving his apprenticeship at age twenty, responded by creating "one of the few overtly political pictures of his career," a lithograph of the incident entitled *Arguments of the Chivalry* (fig. 14). Mocking southern postures of chivalry, it echoed an earlier cartoon by John L. Magee, and it included the comment of abolitionist clergyman Henry Ward Beecher, "The symbol of the North is the pen, the symbol of the South is the Bludgeon."[11]

Later, in the spring of 1860, when Homer was working as a young illustrator for *Harper's Weekly,* the bark *Wildfire* carrying 510 enslaved Africans from the Congo River was captured in the Gulf Stream off Cuba and brought into Key West, Florida, for violation of the federal law prohibiting the importation of slaves. The incident was a stark public reminder that the grim trade continued illegally and that the nation had become a house divided with respect to the issue of race slavery. On June 2, *Harper's* covered the story and ran an engraving (under the heading *The Africans of the Slave Bark, "Wildfire"*) that was based on a daguerreotype made aboard the ship (fig. 15).

The startling image, linking blacks on a ship in the waters off Key West with the "middle passage" of previous generations and the impending breakup of the union, may or may not have made a conscious impression on Homer at the time. At that point in his life, Winslow had never traveled in Florida or the Caribbean, though he had no doubt heard stories of the region from his father's brother, James Homer, for Uncle Jim owned a barque and made regular voyages from New England to Cuba and the West Indies.[12] Key West became a closer reality for all the Homers the following year when Winslow's

FIGURE 14 Winslow Homer, *Arguments of the Chivalry,* 1856

Lithograph, 13⅞ × 20⅜ in. (35.2 × 51.7 cm). Library of Congress, Washington, D.C. (LC-USZ62-38851).

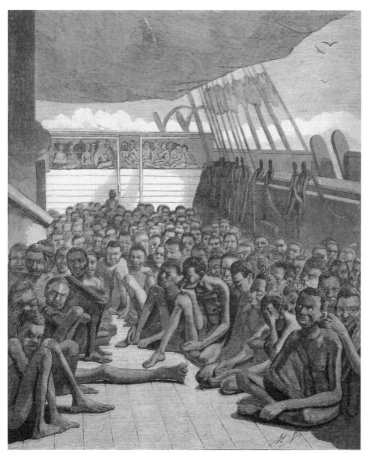

FIGURE 15 *The Slave Deck of the Bark "Wildfire," Brought into Key West on April 30, 1860,* 1860

From *Harper's Weekly,* June 2, 1860. Duke University Library.

younger brother Arthur enlisted in the U.S. Navy and sailed south aboard the *Kingfisher,* part of the Gulf Squadron based at Key West.[13]

Whether or not the dramatic *Wildfire* incident at Key West caught Homer's attention, the outbreak of the Civil War meant that he, like other Americans, had to deal more directly with the meaning and implications of slavery, especially as the South's "peculiar institution" gradually became a more central issue in the war. One small oil sketch that exists in a private collection may provide a clue to the ways in which Homer was wrestling with this matter, artistically as well as intellectually. It shows a profile of a shackled black man who sits hunched over in dejection, with his head nearly touching his drawn-up knees. The man wears a white cloth at the waist and iron manacles around his ankles. The picture is signed "Homer, 1863," and it could stem from visits to Washington, D.C., and Virginia early in the war. While some experts have deemed it a forgery, I suspect that it may well be authentic—a rough early work that is remarkable in its subject matter, if not yet in its execution.[14]

As the 1860s finally drew to a close, Winslow Homer's editors at *Harper's Weekly* asked him to create a two-page spread that would reflect, in visual terms, that tumultuous decade. He solved the challenge by placing a huge cog, labeled the "WHEEL OF TIME," at the center of the page. Clockwise around this form, starting at the bottom, the wheel is inscribed with the individual years, and around it, separate scenes recall the national drama that had unfolded year by year. In the lower left-hand quadrant Homer showed heated political debate and the firing on Fort Sumter. Later views depict battles on land and sea, ending with an optimistic Reconstruction scene of white and black children sitting down together to learn their ABCs.

Logically, the halfway point at the top of this ten-year "wheel of time" should have portrayed scenes from 1865—the surrender at Appomattox or the assassination of President Lincoln. Instead, as Homer sketched out his wood engraving entitled *1860–1870,* he bent the chronology somewhat (fig. 16). He moved 1863 to the high point

FIGURE 16 Winslow Homer, *1860–1870,* 1870

From *Harper's Weekly,* January 8, 1870. 13⅜ × 20½ in. Collection of Duke University Museum of Art, Museum Purchase, Von Canon Fund (1974.2.138).

in the circle, and above it he drew Abraham Lincoln with bright rays behind him. He placed a prominent "Liberty cap" beside the president, who holds out the Emancipation Proclamation in his extended right hand. Like many Americans, black and white, Homer viewed that key step in the emancipation process as a major turning point, not only for the decade but for the young country's entire history.[15]

More than two decades later, when Homer began to frequent the tropics, he again became intrigued with painting black figures. As we have seen, he often linked them with sharks, beginning as early as 1885. An 1889 study, for example, now in the Art Institute in Chicago, depicts a rudderless boat adrift with no mast. Stalks of sugarcane lie along the deck between the reclining black sailor onboard the hulk and the gaping shark (repeated from *Shark Fishing*) that plunges in the foreground. A dark storm cloud hovers ominously in the distance. These elements would all recur in *The Gulf Stream* a decade later. The background storm in *The Gulf Stream* may, when considered geographically, suggest the tempest brewing beyond the horizon in Cuba during the final decades of the nineteenth century. But considered in terms of a deeper chronological background, it brings to mind the long centuries of stormy travail that constituted the African experience in America.

A well-known black spiritual from the nineteenth century summarized slavery's hardships with the refrain, "I've been in the storm so long." Lines from the song—such as "This is a needy time," "Lord, I need you now," and "Just look what a shape I'm in"—invoke the tribulations of enslavement. (Appropriately, historian Leon Litwack chose to call his book about slavery's end in the 1860s *Been in the Storm So Long*.)[16] Any painting of a black man trapped on a boat in the Atlantic and buffeted by storms certainly evokes, at some level, the African slave trade and the collective trauma recalled by blacks as "slavery time" or "them dark days." We must now, therefore, in this deepest portion of our dive into *The Gulf Stream*, try to make sense out of two remaining elements in Homer's painting: the open-mouthed

sharks that swerve fiercely around the boat and the writhing stalks of sugarcane that protrude from the vessel's hold.

Throughout his career, Homer reversed images of hunter and hunted. In his watercolor entitled *Shark Fishing,* for example, which was painted in Nassau in the mid-1880s, he linked a black man with the dangerous fish through the picture's composition. Following the ellipse of the rowboat's transom, a larger unfinished loop links the man's head to the fish's tail, implying a potentially vicious circle. If the man does not catch and eat the shark, the fish may curve around and devour the man. The image also appeared as a woodcut in *Century Magazine* in February 1887. Homer knew from firsthand observation in the South the intimate and practical relation between blacks and sharks; the large fish, discarded by whites as inedible, made nourishing food. In the black neighborhoods of Charleston at the end of the nineteenth century, for example, fish vendors sold their catch with melodious calls: "Shark steak," they would sing out. "Shark steak don't need no gravy."[17]

The tradition of dining on shark seems to stretch far back into the coastal cultures of West Africa. A member of the Dutch West India Company stationed at the Gold Coast in the 1640s commented, "The Moors eat [sharks], but the Dutch do not, because doing so deranges one's head." Another visitor to the same region in 1704 noted that in some places, sharks were "the Negroes' best and most common Food," while "the Europeans never eat them."[18] But if Africans traditionally savored shark, the tables could be turned. Ancestors of the black Charlestonians who dined on shark steak had often themselves, in the parlance of the slave trade, been made into "shark bait." The expression "to be thrown to the sharks" had its origins in the gruesome practices of the middle passage, the forced transit from Africa to America.

Wilhelm Johann Müller, a Lutheran pastor in the service of the Danish African Company, never forgot what he witnessed when "two

old slaves and a half-year-old baby slave died" aboard the slave ship *Patriarcha Jacob* off the island of São Tomé in 1669. "When the corpses were thrown into the sea," Müller recalled, "the old ones were immediately pounced upon by several sharks, as if by hungry lions, and were crushed to pieces and eaten. The half-year-old baby, however, was swallowed whole by a shark which was afraid of [having to share this meal with] other guests."[19] Alexander Falconbridge, who wrote an account of a slave-trading voyage in the eighteenth century, described the demise of one African woman who became depressed and sick, then "refused all food and medical aid" in "her determination to die." She expired within days. Falconbridge remembered vividly that, "on being thrown overboard, her body was instantly torn to pieces by sharks."[20]

Such grim scenes were not isolated events; they were repeated tens of thousands of times over the course of many generations. We recall that Brooke Watson, later Lord Mayor of London, lost his leg to a shark in Havana Harbor in 1749, and the dramatic moment was memorialized in Copley's 1778 painting, *Watson and the Shark* (plate 7). In this picture, too, a black man is aboard a boat, though here he is an emblem of calm and salvation, casting out a rope that is a lifeline (the opposite of a whitecapper's noose). But why were large sharks scouring Havana Harbor during the eighteenth century in the first place? The harsh fact is that captains in the slave trade, after reaching their destination, often threw overboard Africans who had died in the last stages of the Atlantic crossing.

One kind of powerful shark related to the dangerous bull and tiger sharks became well known for accompanying vessels on transatlantic voyages, eager to feed on bodies tossed over the stern. Because of its association with human death, sailors during the seventeenth and eighteenth centuries came to call it the "requiem shark." In 1693, as the English slave trade underwent rapid expansion, Captain Thomas Phillips reported sharks—no doubt requiem sharks—devouring blacks who jumped overboard in African waters: "We

have . . . seen divers[e] of them eaten by the sharks, of which a prodigious number kept about the ships in this place, and I have been told will follow her hence to Barbadoes, for the dead negroes that are thrown over-board in the passage. I am certain in our voyage there we did not want the sight of some every day, but that they were the same I can't affirm."[21]

More than a century later, Captain Richard Drake recounted similar conditions when his ship was attacked by another vessel while buying captives at Bonny, on the coast of modern-day Nigeria. "Many of our slaves jumped overboard," he recalled, "into the jaws of sharks." When highly contagious smallpox broke out aboard the ship during the Atlantic crossing, "the sharks followed us as if they smelled sickness." And they were rewarded. "We soon began to feed corpses to the following sharks and one day hauled sixty bodies out of the hold," Drake reported. "The crew revolted at this work and we had to rely on gangs of slaves to drag the dead heaps from among the living" and throw the victims overboard (fig. 17).[22]

Over the four centuries of the transatlantic slave trade, more than 12 million persons were cast into the voracious maw of the New World plantation system. But many others never reached land alive; several million Africans were thrown overboard into the Atlantic. During the eighteenth century alone, the largest and best-documented century of the trade, more than 6.6 million slaves departed from the African coast while only 5.8 million arrived in the Americas, meaning that roughly 800,000 enslaved persons perished at sea during that one-hundred-year span. All of them were thrown into the Atlantic, some even before they had died. The magnitude of this carnage is difficult to fathom. Consider that only a small portion of the entire Atlantic slave traffic—roughly 6 percent, or about 600,000 people all told—came to North America. This means that more Africans were fed to Atlantic sharks during the eighteenth century than ever reached the North American mainland.[23] The number of corpses thrown overboard was so enormous at the height

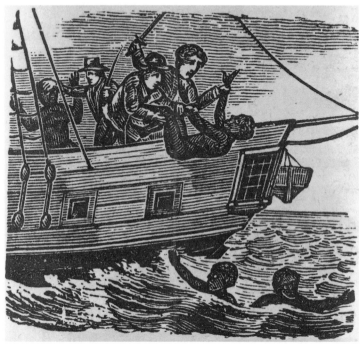

FIGURE 17 Anonymous, *Slaves Being Thrown Overboard from a Slave Ship*, 1836

Woodcut in *The Slave's Friend* (New York, 1836), an antislavery tract. Library of Congress, Washington, D.C. (LC-USZ62-30833).

of the slave trade that certain types of shark may have actually altered their feeding and migration patterns to take advantage of the windfall.

Africans cast into the ocean became shark bait, both figuratively and sometimes even literally. One slave trader who set out from West Africa for Antigua in 1714 reported, "We caught a great many fish in ye passage, especially Sharks. Our way to entice them was by Towing overboard a dead Negro, which they would follow till they had eaten him up." Once caught with human bait, the devouring sharks, according to the captain, proved to be "good victuals if well dress'd, tho' some won't eat them, because they fed upon men." He added, "Ye Negros fed very heartily upon them, which made us salt up several of them to save ye Ship's provision."[24]

Hungry sharks, like greedy slave traders, are thus key elements in the initial chapters of African American history, and this powerful image of Africans caught—like flying fish—between the devil and the deep blue sea was not lost on nineteenth-century American artists. In *Moby-Dick,* Herman Melville describes the *Pequod*'s old black cook, Fleece, preaching a mock sermon to the sharks at the insistence of Stubb, the second mate. Fleece addresses the sharks ironically as "Cussed fellow-critters!" and exhorts them to, "Kick up de damnest row as ever you can." As Mr. Stubb devours whale meat and mocks the cook, Fleece departs, muttering, "Wish by gor! Whale eat Stubb, 'stead of him eat whale. I'm bressed if he ain't more of a shark dan Massa shark hisself."[25]

Homer, like Melville, was sensitive to the powerful historic links between shipboard blacks and Atlantic sharks in ways that later art critics have never been. It is possible to track his inheritance of this telling image through several lines of artistic descent. The association with *Watson and the Shark* has already been mentioned. One version of Copley's famous painting hung in the Boston Museum and was well known to Homer. But the link to another picture that made

its way into the Boston Museum of Fine Arts is also worth tracing briefly.

In 1732, a popular English travel anthology published James Barbot's narrative from the late seventeenth century, "Description of the Coasts of North and South Guinea," with a vivid description of the shark:

> It swims incredibly swift, and great multitudes of them usually follow our slave-ships some hundred leagues at sea, as they sail out from the gulph of Guinea; as if they knew we were to throw some dead corps [*sic*] over board almost every day. If a man happens to fall over-board, and these monsters are at hand, they soon make him their prey; and I have often observ'd, that when we threw a dead slave into the sea . . . one shark would bite off a leg, and another an arm, whilst others sunk down with the body.[26]

This gruesome passage provided the direct inspiration for the poet James Thomson a dozen years later, in 1744, when he introduced into the second edition of his phenomenally popular epic, *The Seasons,* a lurid scene with sharks, Africans, and a "circling typhon."[27] Thompson writes about "the direful shark" who "rushing, cuts the briny Flood." He describes the triple rows of deadly teeth ("His Jaws horrific arm'd with threefold Fate"), and he portrays the lurking shark as "Lur'd by the Scent / Of steaming Crouds, of rank Disease, and Death." Thompson condemns "that cruel Trade, / Which spoils unhappy *Guinea* of her Sons," and goes on to recount how the shark, when given his chance by a storm, devours the

<div align="center">

mangled Limbs
. . . dyes the purple Seas
With Gore, and riots in the vengeful Meal.[28]

</div>

As the eighteenth century progressed, Thomson's image of the shark, "Lur'd by the Scent . . . of rank Disease, and Death," was aggrandized by the international movement to abolish the slave trade. It

was given notorious confirmation in the year 1781 by Luke Collingwood, the captain of a Liverpool slave ship. His vessel, the *Zong,* left African waters in September bound for Jamaica with 442 captives in the hold. Sickness broke out aboard the crowded ship, and supplies of fresh water supposedly began to run low. After sixty slaves had died, Captain Collingwood sensed that he might lose his entire cargo before the captives could be delivered to the Jamaica slave markets. He knew that he could claim insurance for slaves said to be lost at sea in a storm, but not for those who died from disease. Therefore, on the pretext that foul weather was approaching, Collingwood ordered that all the sick Africans—then numbering more than 130—be thrown overboard. The shocking case gained notoriety when Captain Collingwood was brought to trial two years later.[29]

In 1840, the renowned English artist J. M. W. Turner, moved by new publications of this story and by recollections of Thomson's famous poem, as well as by recent debates over ending race slavery in British dominions, created one of his most awesome seascapes: *Slavers Throwing Overboard the Dead and Dying, Typhon Coming On,* or more simply, *The Slave Ship* (plate 8).[30] "Is this picture sublime or ridiculous?" asked William Thackeray. "Indeed I don't know which." "I believe," writes John Ruskin in *Modern Painters,* "if I were reduced to rest Turner's immortality upon any single work, I should choose this."[31]

The picture's style prompted eloquent commentary and rich debate, due largely to the fact that the actual topic of the painting created immense anxiety among observers. They were eager to deflect attention in a more familiar and less shocking direction (as would be the case with *The Gulf Stream* later on). "So great was the controversy over the merits of Turner's manner," writes one cultural historian, "that almost no attention was given to the subject-matter."[32] Thackeray called it "the most tremendous piece of colour that ever was seen," and Ruskin, whose father bought the picture for him as a gift, effused over "the power, majesty, and deathfulness of the open, deep illimitable sea!" As recently as the 1970s an introduction to *The Slave*

Ship asserted, "The focal point of the heroic seascape is not the ship but the setting sun, and the overriding drama is the symphonic display of sky and sea, not the account of man's bestiality."[33]

Whatever the seascape's true focal point, Ruskin eventually found the picture "too painful to live with." In selling it he set in motion dealings that would eventually take the painting on a middle passage of its own across the Atlantic, first to New York and then to Boston, seaports much like London in their deeply entwined traditions of slave trading and abolitionism.[34] In the late 1890s, Turner's masterpiece was on loan to the Museum of Fine Arts in the city of Winslow Homer's birth, and in 1899, Boston's museum purchased the picture with considerable fanfare through the Henry Lillie Pierce Fund for $10,000. When William Morris Hunt, the prominent Boston architect, was asked whether the picture was worth that amount, he replied, "Well, I see a good many ten thousands lying about, but only one *Slave Ship*!"[35]

In 1899, the Museum of Fine Arts, which had purchased Homer's *The Fog Warning* five years earlier, bought an additional oil, *The Lookout—All's Well,* and four of his watercolors, including *Leaping Trout,* but there were no "ten thousands" lying about for the American artist. Although he lived comfortably and earned more than most of his contemporaries, he still felt undercompensated for his painstaking studies, which he considered "quite different from posing a successful lawyer in one's studio light & rattling him off in a week's time to the tune of $3,000." When the prominent dealer-collector Thomas B. Clarke sold 372 American paintings at a four-day sale in 1899, the average price was only $630, and 30 pictures by Winslow Homer brought only $22,345, or an average of $745. "Find out if possible," Homer wrote his New York dealers the following year, "if there is any market value to anything I can do."[36]

The Gulf Stream went unsold for seven years before it was bought by the Metropolitan Museum, so commercial success, though a steady concern, would hardly seem to have been Homer's primary motive in painting the picture, whatever the publicity surrounding the Turner

purchase. Yet, a competitive sense of professional pride, both individual and national, may, at some level, have stirred America's foremost seascape painter to undertake an updated, New World interpretation of the old romantic theme of African facing shark in the stormy Atlantic. The fact that *The Gulf Stream* bears some resemblance to Turner's famous *Slave Ship* was not lost on American commentators; more than one early critic remarked on the underlying similarities between the two pictures in terms of subject matter.[37]

The association of sharks with the middle passage and the plantation world was thus long familiar at the end of the nineteenth century. Americans are still morbidly fascinated by the dangers posed by sharks.[38] It is not surprising, therefore, that people who can barely identify *The Gulf Stream* or its artist can recall the dramatic sharks in the foreground. In sharp contrast, the long stalks of cane that rise out of the dark hold and trail down across the sloping deck to link sailor and shark are among the least observed elements of the picture. But sugarcane resides at the very center of the painting, both literally and figuratively.

Aboard small Gulf Stream boats known as smacks, sugarcane was a common sight. It was a cargo brought from Cuba to Florida for sale in the United States, and it also provided a ready form of nourishment. People often chewed sections of the sweet stalk as a source of energy, much as Americans today might eat a candy bar.[39] Homer observed cane on his first trip to the tropics, and stalks of cane appear in several of his watercolors from the 1880s. In his *Study for "The Gulf Stream,"* probably painted in 1898, the color and pattern of the cane stalks on the sloping deck prefigure the final painting almost exactly.[40] In September 1899, Homer wrote to a friend, "I painted in water colors three months last winter at Nassau, & have now just commenced arranging a picture from some of the studies."[41]

If sharks epitomize the transatlantic slave trade, then sugarcane symbolizes the long and tangled history of New World slavery. Just

as the stalks of sugar in Homer's picture reach down into the dark hold of the black man's boat, sugarcane reaches down into the black past of slavery. And just as the mysterious cane stalks occupy a central position in *The Gulf Stream,* the profitable plant occupied a central place for centuries in the entire Atlantic system. Nowhere did sugar become more important than in Cuba, where the common expression for many generations has been: "*Sin azúcar, no hay país*" (without sugar, there is no country).[42] It was sugar that first enslaved Africans in the Americas; in a cruel irony, it often sustained them as well.[43] The drifting sailor grips a piece of cane in his right hand, and he may well have been chewing cane to stay alive.[44]

In early medieval times, sugar arrived in the Mediterranean from the Levant, and sugar production sprang up on several Mediterranean islands. Eventually, demand for the sweet product gave rise to the concept of the plantation, where gangs of workers produced a single staple crop for a large market.[45] Sugar plantations spread westward from Cypress, Crete, and Sicily to southern Spain. During the fifteenth century, sugar reached the islands of the eastern Atlantic— the Azores, Madeira, the Canaries, and the Cape Verde Islands.[46] The Portuguese introduced cane from Madeira to São Tomé in 1485, and plantations on these Atlantic islands were exporting sugar to Antwerp at the time Columbus sailed west.

By the seventeenth century, West Africans were cultivating "large fields of sugar cane" in the Gold Coast region, where the plant was known as *aggwri* in the Fante dialect of the Akan language. "When the Blacks want to consume it," one European reported, "they break the long cane on their knee, peel it with their teeth, chew it and suck out the sugar-sweet juice. This sweet plant is brought to market every day and eagerly bought up by the women and children." Whether or not coastal Africans occasionally used sugarcane as bait when fishing, as one source claimed, they did regularly carry stalks in their boats to chew for nourishment. "When they want to go fishing, four or five of them take a cane with them to quench their thirst when the sunshine is

very hot, because the sugar-cane is very juicy; and many often make do for a whole day without further food or drink. Since, however, there are no sugar mills here in Guinea, it is only eaten in this way."[47]

Following in the wake of Columbus, Iberian entrepreneurs moved the crop from the eastern Atlantic to the western Atlantic. They also transferred the mill technology for crushing the stalks, the apparatus for boiling the juice and distilling the sugar, and the pattern of plantation labor associated with the crop. Once profit-seeking planters had established sugarcane in Brazil and the West Indies, the system sucked workers out of Africa insatiably and sealed their fate in the Americas. Sugar plantations eventually spread across the tropics from the mouth of the Amazon to the mouth of the Mississippi. In 1700, Portuguese landowners in Brazil and English, French, and Dutch planters in the Caribbean exported nearly sixty thousand tons of sugar. Almost half of it (twenty-five thousand tons) came from the tiny English island of Barbados, which contained only 166 square miles of land.[48] As production in the West Indies expanded and shipping improved, the price of sugar in Europe gradually declined, and what had once been a luxury item became viewed as a substance for common consumption, giving energy to workers and satisfaction to tea drinkers and candy lovers.[49]

Made wealthy by this commerce, plantation owners eager to escape the risky tropical climate of the Caribbean turned into absentee landlords. Many returned to Europe and became powerful lobbyists working to preserve their interests and protect the traffic in African slaves. Quite literally, sugar fueled the transatlantic slave trade. Most of the ten to twelve million Africans brought to the New World lived out their lives on tropical sugar plantations, growing and processing the product that sweetened the tea of Europeans and gave economic power to white colonizers.

African slaves planted cane, cut it, hauled it, and pressed the stalks between huge rollers to extract the juice. Next, slave workers boiled the liquid in huge copper kettles to evaporate the water, leaving brown

sugar, known as *muscovado,* which they packed into massive barrels and loaded aboard ships for Europe, where it would be refined into white sugar. The thick by-product known as molasses was also barreled, and much of it was shipped to England's North American mainland colonies, where it provided a cheap sweetener that could be used at home or distilled into rum. Untold hogsheads of rum from distilleries in New England and elsewhere were then shipped to West Africa and used in the slave trade to procure more workers who would be forced to grow more sugarcane. Whether you think of it as a fateful triangle or a vicious circle, this Atlantic vortex was a devastating and long-lasting maelstrom for Africans.[50]

For Americans such as Homer who had visited Cuba and for all those familiar with the arduous labors of processing cane, the artist's picture hints at the horrors of producing sugar.[51] One foot of the isolated black man touches the stalks of cane, which almost seem to form a chain to shackle his ankle. The sugarcane aboard the *Anna* appears to have been shoved into the dark hold much as cane was fed into the plantation sugar mill by slave workers, hour after hour. Historian Alan Taylor points out that while all phases of sugar production represented "especially hard, monotonous, and dangerous work in tropical conditions," tending the mill was "particularly dangerous, especially for bone-tired people working around the clock." He quotes the grim warning of planter Edward Littleton: "If a Mill-feeder be catch't by the finger, his whole body is drawn in, and he is squeez'd to pieces."[52]

It is worth noting that in black folklore, sugar (both brown and white) has long been a powerful emblem invoked by poets and musicians. Vocalist Bessie Smith used to sing a suggestive song entitled, "Put a Little Sugar in My Bowl." The Rolling Stones' song "Brown Sugar," with an opening lyric about a Gold Coast slave ship bound for New Orleans, was one of the top hits of 1971. In 1995, the Virginia-born black artist D'angelo released his debut album, *Brown Sugar,* for EMI, selling over two million copies and turning the title track, which he wrote, into a hit. A black musical called *Bubbling Brown Sugar* ran

on Broadway in 1976, and in 2002 a Hollywood film centering on an African American love interest bore the familiar title *Brown Sugar*. And so on.

But we have not yet squeezed the cane image dry; far from it. The people who raised cane also *raised Cain*. The word, with its different spellings, is rich in symbolic meaning, for it can also invoke the story of Cain and Abel. In Genesis, chapter 4, Cain, a tiller of the soil, offered up the fruit of the earth as his sacrifice to God. When it was rejected, Cain killed his brother, Abel, whose offering had been accepted. As punishment for his sin, the surviving brother was denied the fruits of the soil and condemned by the Lord to be a fugitive and a wanderer on earth, and "the Lord set a mark upon Cain, lest any finding him should kill him." From medieval times onward, the "mark of Cain" was often taken by European Christians to be physical blackness. An English thirteenth-century psalter at St. John's College, Cambridge, depicts "God cursing and marking Cain" and shows Cain with the devil's horns and Negroid features. A fourteenth-century manuscript, the English Bohun Psalter in Oxford's Bodleian Library, depicts the Lord blackening the face of Cain in a similar scene, entitled "God marking Cain."[53]

Inevitably, the biblical name suggests the famous line uttered by Cain in Genesis 4, verse 9: "Am I my brother's keeper?" As pressure grew in England in the 1780s to force an end to the traffic in Africans, the London Anti-slavery Society turned this Old Testament query inside out, taking as its emblem a shackled black man who asks, on bended knee, "Am I Not a Man and a Brother?" The entrepreneur Josiah Wedgwood emblazoned this device on a variety of china teacups and porcelain pendants, and the image and the quotation became familiar on both sides of the Atlantic.[54]

Associations between the biblical Cain and sugarcane were already in the air at the end of the eighteenth century, as can be seen in the poetry of Phillis Wheatley (1753–1784), an African American who crafted her verses in New England. Wheatley, herself a survivor of

the infamous slave trade, had been brought from Africa in 1761 at the age of eight and sold to a Boston merchant named John Wheatley. As an observant kitchen hand, she understood that dark brown sugar could be refined into white, cone-shaped sugar loaves, and as a literate teenager in a Christian household, she also knew her Scriptures. In a brief elegy entitled "On Being Brought from Africa to America," she included lines about race and religious conversion:

> Some view our sable race with scornful eye,
> "Their colour is a diabolic die."
> Remember, *Christians, Negroes,* black as *Cain,*
> May be refin'd, and join th' angelic train. [55]

Wheatley mastered the art of English poetry at an early age, and she likewise understood the dynamics of American racism. She became the first of many black authors—in a lineage that reaches up to and beyond Homer's lifetime—to link cane in the fields with Cain in the Bible.

In the early 1920s, some six generations after Wheatley's untimely death, a light-skinned African American writer named Jean Toomer found himself working as a substitute principal at the Sparta Agricultural and Industrial Institute in rural Georgia. Toomer was born in 1894, five years before Homer painted *The Gulf Stream,* and he grew up in Washington, D.C. But the sojourn in Georgia and his fascination with his surroundings there inspired him to consider his own southern roots. Over several years he developed a series of stories about the pain and tribulation of life in the South. When he published the modernist collection to positive reviews in 1923, he used *Cane* as the title. "*Cane* is about the search for roots," writes critic Roger Rosenblatt, "and about the penalties a people suffers by being uprooted." He goes on to underscore a further meaning of the four-letter word. "The title refers to the idea of support as well. All of the characters in *Cane* vainly seek a cane or something to lean on. But there may be a deeper pun here, too. Cain and Abel were the sons of Eve, equal at

their births except that by divine caprice or mystery Cain was automatically rejected by God and Abel was the favored boy."[56]

In Genesis, of course, Cain does not die an early death; he goes on to "dwell in the land of Nod, on the East of Eden," where he builds a town and begins a family. But what will become of Homer's central figure—and, for that matter, all those he appears to represent? We know that prospective buyers pressed art dealer Roland Knoedler to find out more about the painting from the reclusive artist. When the dealer passed along comments about the "horror" of Homer's subject, the artist replied with several caustic letters. In one he wrote sardonically,

> The criticisms of the Gulf Stream by old women and others are noted. You may inform these people that the Negro did not starve to death. He was not eaten by the sharks. The waterspout did not hit him. And he was rescued by a passing ship which is not shown in the picture.
> Yours truly,
> Winslow Homer[57]

As he grew older, Homer, like Melville, became increasingly callous toward literal-minded and sentimental artistic consumers. In 1900, he wrote with irritation to Knoedler about another work: "If you want more sentiment put into this picture I can with one or two touches—in five minutes time—give it the stomach ache that will suit any customer." Later he would throw up his hands and write, "What is the use? The people are too stupid. They do not understand."[58]

Perhaps Homer's ultimate and most eloquent response to viewers' questions about "what happened" came in the form of a haunting watercolor entitled *After the Hurricane, Bahamas,* sometimes called *After the Tornado, Bahamas* (plate 9). Also painted in 1899, it shows the body of a black sailor slumped on a beach. Beside him rest the broken transom and sternpost of his flimsy craft. Apparently these remains, along with a useless rudder and shattered tiller, are all that is left of his little boat,

which was clearly even smaller than the *Anna*. The pounding waves and dark clouds of an Atlantic storm recede in the distance.

Throughout his career, Homer frequently put together separate images, loosely related, that seemed to connect in a sequence over time. Arranged in a certain way, not necessarily in the order they were painted, the pictures take on something of a narrative flow, the way modern moviemakers lay out a storyboard in order to watch their plot unfold. As art historian Bruce Robertson has observed:

> "Meaning" in Homer's paintings normally resolves itself into a story, whether it is one contained within the painting or one seen in comparison with other works. Not surprisingly, Homer never entirely abandoned his roots as a journalist committed to recording events. Even within the simplest landscapes, there is always some action, something going on that implies a before and after. Although each work certainly exists on its own, we understand them better when we view them together, as Homer himself did. The juxtaposition of his paintings reshapes them into explicit sequences or into repetitions and adoptions of the same motif.[59]

Over the course of four decades, it had become Homer's practice to build profound ambiguities into many of his images, allowing—even forcing—viewers to come to their own conclusions. Even on the rare occasion when he borrowed an image from another artist, as he did in 1873, he was drawn to an ambiguous scene. When the steamship *Atlantic* was destroyed on the rocky coast of Nova Scotia, *Harper's* reported that "over five hundred souls were hurried without warning into eternity, and of all the women and children on board but one saved!" Survivors were brought into Boston and New York, where *Harper's* artists worked on several depictions of the dramatic wreck. Homer, no doubt facing publication deadlines, used an engraving by Daniel Huntington for Longfellow's *Wreck of the Hesperus* to design a picture of a young woman washed ashore (fig. 18). Both the viewer and the old salt who has found her wonder whether, against

FIGURE 18 Winslow Homer, *The Wreck of the "Atlantic"—Cast Up by the Sea,* 1873

From *Harper's Weekly,* April 26, 1873. 9⅛ × 13¾ in. Collection of Duke University Museum of Art, Museum Purchase, Von Canon Fund (1974.2.162).

all odds, she could be the one woman who has miraculously survived the disaster.[60]

Far from answering any lingering doubts about *The Gulf Stream,* Homer's *After the Hurricane* compounds questions raised by the earlier painting, for it is as stark and unresolved as the other picture. Has the waterlogged black figure succumbed completely, losing not only his boat but his own life as well? Or is he still alive and breathing, capable of standing again on his own, or at least able to respond in the unlikely event that help should arrive?

Viewers choose to read the watercolor in different ways, for it is a subtle Rorschach test that puts the burden of interpretation back on the viewer. What seems obvious to one witness may seem implausible to another. Jean Gould, who published a popularized biography of Homer in 1962, speculates that the picture was "inspired by the muscular boys whose livelihood was catching turtles for the market boats" at Rum Cay, a tiny island southeast of Nassau in the Bahamas. As Gould imagines it, "After a violent tropical storm the sight of one of these strong boys lying dead on the beach, his splintered sloop nearby at the spot where the storm had tossed them, evoked the telling, dramatic 'After the Tornado.'"[61]

Homer biographer Gordon Hendricks takes another view: "It has often been said that the black man in this watercolor is dead; I believe he is merely exhausted: his posture is quite unlikely for a dead man."[62] Helen Cooper, an authority on Homer's watercolors, argues that *After the Hurricane* "can be seen as the final image in a narrative sequence about the power of nature and man's ineffective struggle against it." She too suspects that the young black, who "lies curled on his side on the white beach, his head cradled on his arm," is "still alive," as suggested by his "relaxed position." For her, the exhausted man "has fallen into a deep sleep on the warm sand. . . . Muscled and gleaming, he is like a magnificent animal, who, unresisting, accepts nature's power over his life." She sees the painting as dreamlike and symbolic, without any relation to the wider world or the times in which

it and *The Gulf Stream* were painted.[63] This traditional perspective on Homer's masterful oil painting and the related watercolor no longer seems sufficient.

Whatever else we observe in *The Gulf Stream,* and there is a great deal to see, Americans may now be ready to accept that the canvas deals in subtle and extended ways with slavery, U.S. imperialism in the Caribbean, southern race wars, and Jim Crow segregation. Putting aside generations of fierce avoidance, by critics and public alike, we can begin to realize that Homer posed more than the recognizable personal and universal questions. Subtly, he also invited viewers to contemplate, in all its dimensions, a particular intractable puzzle: the tangled, painful, and long-standing dilemma of American race relations. He challenged us to ask ourselves about the ongoing interconnections between black and white Americans—past, present, and future. But because we as a nation have for generations denied this aspect of our heritage, it has taken us almost a century to realize this.

Maybe—at least subconsciously—we have been aware of these powerful themes in the painting all along. Could it be, ironically, that they help explain why this picture became so widely known and is so well remembered? Perhaps in his tight-lipped Yankee way, Homer was asking, as the Reverend Martin Luther King Jr. would ask two generations later, whether "the sons of former slaves and the sons of former slaveowners will be able to sit down together at a table of brotherhood."[64] Addressing such imponderable questions can give us a deeper understanding of the painting, and of ourselves. Only then can we fully comprehend, in Adrienne Rich's phrase,

> the damage that was done
and the treasures that prevail.

Notes

Introduction: Diving into the Wreck

1. Many interesting books have centered on single pictures over the years, and I have drawn insight and encouragement from a variety of them. See, for example, John Gage, *Turner: Rain, Steam and Speed* (New York: Viking, 1972); Roy C. Strong, *Van Dyck: Charles I on Horseback* (New York: Viking, 1972); Joel Isaacson, *Monet: le déjeuner sur l'herbe* (New York: Viking, 1972); Reinhold Heller, *Edvard Munch: The Scream* (New York: Viking, 1973); Loren Partridge and Randolph Starn, *A Renaissance Likeness: Art and Culture in Raphael's Julius II* (Berkeley: University of California Press, 1980); Russell Martin, *Picasso's War: The Destruction of Guernica, and the Masterpiece that Changed the World* (New York: Dutton, 2002).

2. From *Diving into the Wreck: Poems 1971–1972* by Adrienne Rich. Copyright © 1973 by W. W. Norton & Company, Inc. Excerpted by permission of the author and W. W. Norton & Company, Inc. Copyright 1973 by Adrienne Rich.

3. J. M. Coetzee, *Foe* (London: Penguin, 1987), 141.

4. Marcus Wood, *Blind Memory: Visual Representations of Slavery in England and America, 1780–1865* (New York: Routledge, 2000), 301, 305.

CHAPTER ONE

The Personal: A Painter and His Picture

1. In nineteenth-century New England, devout women often named their childen after admired clerics. Henrietta Homer convinced her husband to name the boy for Dr. Hubbard Winslow, the popular Congregational minister

at Boston's Bowdoin Street Church where they were members. (Dr. Winslow had succeeded Rev. Lyman Beecher—the famous father of Harriet, Catherine, and Henry Beecher—in the Bowdoin Street pulpit.) Gordon Hendricks, *The Life and Work of Winslow Homer* (New York: Abrams, 1979), 12–13.

2. As Homer scholar David Tatham points out: "When the picture was first exhibited, at the Pennsylvania Academy of the Fine Arts in January 1900, neither the ship nor the gray paint on the horizon was part of it. Homer added these details later in the year to heighten the distinctive characteristics of the Gulf Stream—its color and its storminess—by contrasting it with the ocean beyond its edge. He noted at the time that in making these changes he had added 'more of the Deep Sea water.' A photograph of the painting taken at its original showing in Philadelphia documents the changes Homer made to establish this contrast." David Tatham, "Winslow Homer and the Sea," in exhibit catalog from the Memorial Art Gallery of the University of Rochester, *Winslow Homer in the 1890s: Prout's Neck Observed* (New York: Hudson Hills Press, 1990), 76.

On page 75, Tatham reproduces the 1900 photograph from *Pennsylvania Academy of the Fine Arts, Catalogue of the Sixty-ninth Annual Exhibition,* January 15 to February 24, 1900, second edition.

3. *Harper's Weekly,* November 10, 1860. On December 8, again using a Brady photograph, Homer provided a dour image of "Hon. Roger B. Taney, Chief-Justice of the United States," the author of the controversial *Dred Scott* decision in 1857, which had declared that African Americans, whether slave or free, had "no rights which the white man was bound to respect." In subsequent weeks he generated separate group portraits of the congressional delegations from the seceding states of South Carolina, Georgia, and Mississippi. The last picture, dated February 2, 1861, featured Jefferson Davis. An unsigned *Harper's* image, "Inauguration of President Jefferson Davis of the Southern Confederacy, at Montgomery, Alabama, February 18, 1861," published on March 9, 1861, has also been attributed to Homer by some scholars.

4. One biographer comments that this picture "is today one of the best known from the artist's hand and one of the best liked in American art. Homer was one of those rare artists who could be both good and popular at the same time. Generally, art depends for its significance on its originality,

and almost by definition what is original is not understood and therefore not liked. And the reverse is often true: if it's popular it isn't good. But in *A Fair Wind* there is sauce for both the sophisticated and the Philistine. This is partly because of the story, which is told with excitement and in rich color, appealing to the masses. And because the story is told with strength and beauty, it appeals to the *cognoscenti.*" Hendricks, *The Life and Work of Winslow Homer,* 118.

5. Homer used this familiar device of the gaze frequently and effectively. Time and again, we as viewers are positioned so as to "watch the watcher." First we are drawn into the foreground of the picture, trying to read the posture and thoughts of a central figure; then we are directed by their gaze to imagine what is happening in the distance and to consider how they are reacting to it.

6. Lloyd Goodrich, *Winslow Homer* (New York: published for the Whitney Museum of American Art by Macmillan, 1944), 162; William Howe Downes, *The Life and Works of Winslow Homer* (Boston: Houghton Mifflin, 1911), 134–35. See also Natalie Spassky, "Winslow Homer at the Metropolitan Museum of Art," *Metropolitan Museum of Art Bulletin* 39 (spring 1982): 1–48.

7. Goodrich, *Winslow Homer,* 187; Downes, *Life and Works of Winslow Homer,* 135.

8. Bruce Robertson, *Reckoning with Winslow Homer: His Late Paintings and Their Influence* (Bloomington: Indiana University Press, 1990), chap. 4, "Americanism and Realism," 68.

9. Quoted in ibid., 69.

10. Kenyon Cox, "Three Pictures by Winslow Homer in the Metropolitan Museum," *Burlington Magazine* (London) (November 1907): 123–24. As a competitive younger artist, Cox was frequently begrudging and ambiguous in his praise for Homer: "The tubby boat has been objected to by experts in marine architecture, and the figure of the negro is by no means faultless in its draughtsmanship. . . . But these things scarcely obscure the dramatic force of the composition, which renders it one of the most powerful pictures Homer ever painted. Nor is it merely a piece of illustration."

11. Goodrich, *Winslow Homer,* 161.

12. Cox, "Three Pictures." Other reviews by Cox, "Homer's perennial critic," appeared in *Nation* and the *New York World.* See Philip C. Beam,

Winslow Homer at Prout's Neck (Boston: Little, Brown, 1966), 171; Isabel Hoopes, "The Story of a Picture," *Mentor* (August 1929): 34. Hoopes's popular commentary, written a generation later, borrows unashamedly from Cox and Downes: "Homer is often lacking in technic, but his painting of the motion of the boat—its helpless sliding into the troughs of the waves—is remarkable. Powerful too is the painting of the moisture-laden air, and of the blue sea with its ruddy flecks and white spray. The hungry sharks which dart and turn around the small craft form a contrast with the sullen laziness of the ill-fated mariner, and the distant ship that cannot possibly see its fellow in distress accentuate the drama of the situation. Like most of the oil paintings by this artist, 'The Gulf Stream' is not a drawing-room subject."

13. Beam, *Prout's Neck,* 170.

14. Downes, *Life and Works of Winslow Homer,* 135.

15. Beam, *Prout's Neck,* 170–71.

16. Barbara Novak, *American Painting of the Nineteenth Century* (New York: Praeger, 1969), 187.

17. Roger B. Stein, *Seascape and the American Imagination* (New York: published for the Whitney Museum of American Art by C. N. Potter, 1975), 112.

18. John Berger, *Ways of Seeing* (Harmondsworth: Penguin, 1972), 15–16.

19. Ibid., 13.

20. I deal briefly with the process of denial regarding early African American history in Peter H. Wood, "Slave Labor Camps in Early America: Overcoming Denial and Discovering the Gulag," in *Inequality in Early America,* ed. Carla Gardina Pestana and Sharon V. Salinger (Hanover: University Press of New England, 1999), 222–38.

21. Nicolai Cikovsky Jr. and Franklin Kelly, *Winslow Homer* (New Haven: Yale University Press, 1995), 369.

22. "Tragedy and Apocalypse" is the apt title of a chapter on late-nineteenth-century American sea pictures in Stein, *Seascape.* See also Wallace S. Baldinger, "The Art of Eakins, Homer and Ryder: A Social Re-evaluation," *Art Quarterly* 9 (summer 1946): 212–33. Though he does not refer to *The Gulf Stream,* Baldinger explores works of literature to show "a mind divided against itself, noted as the prevailing state in American society at the turn of the century," and finds a "visual counterpart to the state of nervous indecision . . . in both the subject and the form" of several paintings. He summarizes the

fin-de-siècle malaise in words that suit Homer's picture: "Things were probably not exactly what they seemed, but who could tell just what they were or where they were drifting" (233). Incidentally, the noun *drift,* which applies in nautical terms to *The Gulf Stream,* also became a popular word for social and political commentary after 1900, as in Walter Lippmann's *Drift and Mastery: An Attempt to Diagnose the Current Unrest* (New York: M. Kennerley, 1914).

23. Geoffrey Chaucer, "The Man of Law's Tale," in *The Canterbury Tales.* The passage and the picture are reprinted in Corcoran Gallery of Art, *Albert Pinkham Ryder* (Washington, D.C.: The Gallery, 1961), frontispiece and 42.

24. Reprinted in Stein, *Seascape,* 111–12. Writing critically and suggestively about Homer's earlier painting *The Life Line,* Stein concludes: "This chilling sense of the vast indifference of the universe to the human condition prompted both Homer and Crane into gestures of aesthetic assertiveness, to use form as a defensive ironic strategy. The aesthetic structure, the formal ordering of images on the canvas, gives what life and God and the universe withhold from man and woman" (111–12).

25. Helen A. Cooper, *Winslow Homer Watercolors* (New Haven: Yale University Press, 1986), 217.

26. Stein, *Seascape,* 112. Both Copley's 1778 picture and Allston's 1804 painting were in the Boston Museum of Fine Arts and would have been familiar to Homer.

27. Hemingway's posthumous novel, *Islands in the Stream* (New York: Scribner, 1970), concerns an artist named Thomas Hudson whose Caribbean paintings are similar to Homer's. (A 1997 paperback edition of the novel uses a Homer watercolor as a cover illustration.) In a piece for *Esquire* (April 1936) entitled "On the Blue Water: A Gulf Stream Letter," Hemingway argues that fishing in the Gulf Stream was even more dramatic than hunting big game in Africa: "In the first place, the Gulf Stream and the other great ocean currents are the last wild country that is left. Once you are out of sight of land and the other boats you are more alone than you can ever be hunting and the sea is the same as it has been since before men ever went on it in boats. In a season fishing you will see it oily flat as the becalmed galleons saw it while they drifted to the westward; white-capped with a fresh breeze as they saw it running with the trades; and in high, rolling blue hills the tops blowing off them like snow as they were punished by it" (31).

28. Ernest Hemingway, *The Old Man and the Sea* (New York: Scribner, 1952), 9. Like Homer, Hemingway refused to engage in interpretation of his work. When asked in 1952, he responded: "There isn't any symbolism. The sea is the sea. The old man is an old man. The boy is a boy and the fish is a fish. The sharks are all sharks no better and no worse."

29. Cikovsky and Kelly, *Winslow Homer,* 370.

30. Ambiguities about Homer's painting extend even to the name of the boat, which has been read as ANN, ANNE, or, most recently, ANNIE (Cikovsky and Kelly, *Winslow Homer,* 382). Another boat, in *Sponge Fishing* (1885), is clearly the ANNIE out of Nassau, but in a large-scale detail from *The Gulf Stream* showing the vessel's stern (Hendricks, *The Life and Work of Winslow Homer,* 249), the letters seem to me best read (just barely) as ANNA.

31. Gabriel García Márquez, *The Story of a Shipwrecked Sailor* (1970; English edition, New York: Knopf, 1986), 59, 61.

32. For an intriguing treatment of Géricault's *Raft of the Medusa* and the story of its creation, see Julian Barnes, *A History of the World in 10½ Chapters* (New York: Knopf, 1989), chap. 5, pt. 2.

33. Hendricks, *The Life and Work of Winslow Homer,* 256, 258.

34. Homer had recorded other tempests earlier, in the mid-1880s, when he first visited Key West, Cuba, and the Bahamas. His 1885 watercolor, *Tornado, Bahamas,* appeared as an engraving entitled *A Hurricane* in the *Century Magazine* of February 1887. See Patti Hannaway, *Winslow Homer in the Tropics* (Richmond, Va.: Westover, 1973), 148–49.

35. Joel Chandler Harris, "The Sea Island Hurricanes," *Scribner's Magazine* 15 (February 1894): 229–47; 15 (March 1894): 267–84. One of the pictures by Daniel Smith, entitled *Left by the Tide* (236), is similar to Homer's later *After the Hurricane* (1899) in both subject and tone.

36. Hannaway, *Homer in the Tropics,* 261–69.

37. "What Homer had learned in his finest work," observes art scholar Roger Stein, "was to translate his sense of the sublime into radically simple, even stark, tragic pictorial statements of the brute power and force of the sea" (Stein, *Seascapes,* 112).

38. Downes, *Life and Works of Winslow Homer,* 133.

39. Peter H. Wood, "Waiting in Limbo: A Reconsideration of Winslow Homer's *The Gulf Stream,*" in *The Southern Enigma: Essays in Race, Class, and Folk*

Culture, ed. Walter J. Fraser Jr. and Winfred B. Moore Jr. (Westport, Conn.: Greenwood Press, 1983), 94n. The publisher somehow managed to print the title image in reverse, making it something of a collector's item, I suppose.

40. Ibid., 88.

41. Henry Adams, "Mortal Themes: Winslow Homer," *Art in America* 71 (February 1983): 112–26. Also see the impressive article by Jules David Prown, "Winslow Homer in His Art," *Smithsonian Studies in American Art* 1 (spring 1987): 31–45.

42. Hugh Honour, *The Image of the Black in Western Art,* vol. 4, pt. 2 (Cambridge: Harvard University Press, 1989), 202.

43. Elizabeth Johns, *Winslow Homer: The Nature of Observation* (Berkeley: University of California Press, 2002), 155–56.

44. Natalie Spassky et al., *American Paintings in the Metropolitan Museum of Art,* vol. 2 (New York: Metropolitan Museum of Art in association with Princeton University Press, 1985), 483–96.

45. Cikovsky and Kelly, *Winslow Homer,* 383.

46. In his most animated early drawing, Winslow depicted his father traveling to California not by land or sea, but by air. This energetic pencil sketch in the Boston Museum of Fine Arts shows Charles riding a steam-powered, cigar-shaped rocket across the country, shovel and wheelbarrow strapped to his back, and making a crash landing in the gold fields (Hendricks, *Life and Work of Winslow Homer,* 18–19). The image was less farfetched than it seems. A New England mural painter and inventor named Rufus Porter, who had founded *Scientific American,* was busily promoting his designs for several futuristic airships. One was "shaped like a long cigar" and driven by two "propellers with clockwork motors"; the other was to be "a hydrogen-filled flying ship 800 feet long and capable of carrying a hundred passengers across the continent in three days." Winslow had undoubtedly seen a pamphlet for Porter's "aerial steamer." Rhoda R. Gilman, ed., *A Yankee Inventor's Flying Ship: Two Pamphlets by Rufus Porter* (St. Paul: Minnesota Historical Society, 1969), 1.

47. Interestingly, although he executed hundreds of sea paintings, Homer almost never painted a ship coming toward the viewer; the boats are almost invariably moving away. One exception, the watercolor *Diamond Shoal* (1905), shows the bow of a vessel in distress.

48. Hendricks, *Life and Work of Winslow Homer,* 236–37. Also see Philip Conway Beam, "Winslow Homer's Father," *New England Quarterly* 20 (March 1947): 51–74.

49. Hendricks, *Life and Work of Winslow Homer,* 177.

50. Hannaway, *Homer in the Tropics,* 156–69. Hannaway's book (which lacks footnoted documentation) misdates *The Gulf Stream* as 1889 (169).

51. This undated sketch, in the collection of Lois Homer Graham, may be seen in Cikovsky and Kelly, *Winslow Homer,* 369.

52. Cikovsky and Kelly, *Winslow Homer,* 369. Elsewhere, Cikovsky has noted that during the 1890s, "by increasingly mirroring his feelings and drawing recollectively on his experiences, Homer's art also became inward and private in ways that it had never been before." The "imminence of death," he observes, and the "stark immediacy of mortality" became "an important presence" in the artist's work. See Nicolai Cikovsky Jr., *Winslow Homer* (New York: Abrams, 1990), 119.

53. Cikovsky and Kelly, *Winslow Homer,* 369.

54. Ibid., 370 (emphasis added). I shall return to these important phrases.

55. An excellent recent example of this genre is Bruce Robertson, *Reckoning with Winslow Homer: His Late Paintings and Their Influence* (Bloomington: Indiana University Press, 1990).

56. For recent examples of a distinguished historian discussing art in its cultural and social context, see the works of Simon Schama: *The Embarrassment of Riches: An Interpretation of Dutch Culture in the Golden Age* (Berkeley: University of California Press, 1988), *Landscape and Memory* (New York: Knopf, 1995), and especially *Rembrandt's Eyes* (New York: Knopf, 1999).

57. Berger, *Ways of Seeing,* 13.

CHAPTER TWO

The Present: Looking South from Prout's Neck

1. For articles on Homer before 1975, see Melinda Dempster Davis, *Winslow Homer: An Annotated Bibliography of Periodical Literature* (Metuchen, N.J.: Scarecrow, 1975). For a bibliography of books from the same era and a useful "Checklist of Works by Homer in Public Collections in the United States," see Gordon Hendricks, *The Life and Work of Winslow Homer* (New York: Abrams, 1979). For more recent references, see especially the bibli-

ography in Nicolai Cikovsky Jr. and Franklin Kelly, *Winslow Homer* (New Haven: Yale University Press, 1995), 414–18.

2. Exceptions include Karen M. Adams, "Black Images in Nineteenth-Century American Painting and Literature: An Iconological Study of Mount, Melville, Homer and Mark Twain" (Ph.D. diss., Emory University, 1977); Michael Quick, "Homer in Virginia," *Los Angeles County Museum of Art Bulletin* 24 (1978): 60–81; Mary Ann Calo, "Winslow Homer's Visits to Virginia during Reconstruction," *American Art Journal* 12 (winter 1980): 4–27. See also Sidney Kaplan, "The Negro in the Art of Homer and Eakins," *Massachusetts Review* 7 (winter 1966): 105–20, which is based on notes for the catalog of a pioneering exhibition at the Bowdoin College Museum of Art in Brunswick, Maine, during the summer of 1964 entitled "The Portrayal of the Negro in American Painting, 1710–1963." Among interesting recent Homer essays that give attention to race are Lucretia Giese, "Winslow Homer: 'Best Chronicler of the War,' " and David Park Curry, "Winslow Homer: Dressing for the Carnival," both in *Winslow Homer: A Symposium,* ed. Nicolai Cikovsky Jr. (Hanover, N.H.: University Press of New England, 1990). A more general overview from the same year is Albert Boime, *The Art of Exclusion: Representing Blacks in the Nineteenth Century* (Washington, D.C.: Smithsonian Institution Press, 1990), which builds on Boime's earlier article, "Blacks in Shark-Infested Waters: Visual Encodings of Racism in Copley and Homer," *Smithsonian Studies in American Art* 3 (winter 1989): 19–47.

3. "Homer was early familiar with Negro subject matter," Locke writes, "and rendered it in realistic genre. Later, from his travels in the West Indies, a more romantic style came into his Negro portraiture, as in the famous *Gulf Stream*." According to Locke, "Homer is chiefly responsible for the modern revival of interest in the Negro subject." See Alain Locke, *The Negro in Art: A Pictorial Record of the Negro Artist and of the Negro Theme in Art* (1940; reprint, Chicago: Afro-Am Press, 1969), 205.

4. Peter H. Wood, "Waiting in Limbo: A Reconsideration of Winslow Homer's *The Gulf Stream*," in *The Southern Enigma: Essays in Race, Class, and Folk Culture,* ed. Walter J. Fraser Jr. and Winfred B. Moore Jr. (Westport, Conn.: Greenwood Press, 1983), 75–94. Boime builds on this interpretation in *The Art of Exclusion* (35–46) and offers much that is of value in expanding this approach.

5. See *The Image of the Black in Western Art,* the Menil Foundation's multivolume survey that began publication in 1976 and is nearing completion through Harvard University Press. The rich archive for this extraordinary project is now housed at Harvard University.

6. Peter H. Wood and Karen C. C. Dalton, *Winslow Homer's Images of Blacks: The Civil War and Reconstruction Years* (Austin: University of Texas Press, 1988), 14. This book complemented an exhibition (curated by the two authors) that appeared at the Menil Collection, Houston; the Virginia Museum of Fine Arts, Richmond; and the North Carolina Museum of Art, Raleigh.

7. *Expulsion of Negroes and Abolitionists from Tremont Temple, Boston Massachusetts, on December 3, 1860,* in *Harper's Weekly,* December 15, 1860. John Brown, convicted of leading a raid on the federal arsenal at Harper's Ferry, had been executed in Charlestown, Virginia, on December 2, 1859. In 1936, one scholar suggested that this image and several others attributed to Winslow Homer might have been designed instead by William J. Hennessey. See Allen Evarts Foster, comp., "Check List of Illustrations by Winslow Homer in *Harper's Weekly* and Other Periodicals," *New York Public Library Bulletin* 40 (October 1936): 842–52.

8. *Harper's Weekly,* January 17, 1863. In October 1862, President Jefferson Davis asked Virginia to draft 4,500 blacks to help fortify the city of Richmond, so that "whites could fight more and dig less." Given the date that Homer's wood engraving appeared, it seems likely that at one important level, *A Shell in the Rebel Trenches* deals with the Emancipation Proclamation, even though (to my knowledge) the connection has never been pointed out. After all, Lincoln's explosive message had been lobbed into the South less than three weeks earlier. The proclamation was aimed specifically toward "all persons held as slaves within any State, or designated part of the State, the people whereof shall be in open rebellion against the United States," and it was causing consternation, disruption, and excitement behind Confederate lines.

9. Wood and Dalton, *Winslow Homer's Images of Blacks,* 55.

10. Ibid., 52–57.

11. Calo, "Winslow Homer's Visits to Virginia during Reconstruction," 4–27. For a well-researched children's book on this return to Virginia, see Amy Littlesugar, *Jonkonnu: A Story from the Sketchbook of Winslow Homer* (New York:

Philomel Books, 1997). A well-illustrated introduction to *The Gulf Stream* for young readers (in the series Let's Get Lost in a Painting) is Ernest Goldstein, *Winslow Homer: The Gulf Stream* (Champaign, Ill.: Garland, 1982).

12. I have often wondered whether, during his stay on the Yorkshire coast, Homer came in contact with the young photographer Frank Sutcliffe, or perhaps saw his work. Sutcliffe (1853–1941) was a portrait photographer who ran a studio in Whitby, a coastal town located south of Newcastle-on-Tyne. According to his biographer, Sutcliffe worked hard during the summer months and then roamed the docks and waterfronts, taking "photographs for his own satisfaction" of North Sea net-menders and fisherfolk, both men and women. We know that Homer traveled down the coast from Cullercoats at some point to Scarborough, Flamborough Head, and Bridlington—all well beyond Whitby. We also know that in 1881, while Homer was visiting the towns clustered around the mouth of the Tyne River, Sutcliffe won a prize for the best photograph at an exhibit in Newcastle. Many of Sutcliffe's pictures appear strikingly similar in subject and tone to some of Homer's creations. See Michael Hiley, *Frank Meadow Sutcliffe* (New York: Aperture, 1979), 91; see especially the images on pages 13, 21, 23, 31, 37, 39, 45, 47, and 69. Some of these photographs are even more Homer-like than the ones published in Cikovsky and Kelly, *Winslow Homer,* 174–76, in which Franklin Kelly's essay also makes mention of Sutcliffe.

13. See Franklin Kelly, "A Process of Change," in Cikovsky and Kelly, *Winslow Homer,* especially 173.

14. Philip C. Beam, *Winslow Homer's Magazine Engravings* (New York: Harper & Row, 1979), 1–3. According to Beam, who stresses this division even more than other biographers,

Homer's two separate careers occurred in two entirely different places and times and according to two drastically contrasting life-styles. From 1883 until his death in 1910 Homer lived an almost hermit-like existence in the comparative isolation and desolation of Prout's Neck, Maine, a rocky and then little-settled promontory a few miles south of Portland harbor. There he lived as a bachelor in a wooden studio-home whose balcony overlooked the Atlantic. . . . Homer has been described as a single man with two sides as drastically different as Dr. Jekyll and Mr. Hyde because his voluminous body of engravings seems to have come

from an entirely different personality, time, and place than the paintings most often associated with his career. . . . In order to avoid too great a contrast, it is necessary to seek out the marks of continuity.

15. Donald P. DeNevi and Doris A. Holmes, eds., *Racism at the Turn of the Century: Documentary Perspectives, 1870–1910* (San Rafael, Calif.: Leswing Press, 1973).

16. Beam, *Prout's Neck,* 172–73.

17. Letter of February 17, 1902, quoted in *Winslow Homer: A Symposium,* ed. Cikovsky, 153, note 12. Slightly different versions appear in Nicolai Cikovsky Jr., *Winslow Homer* (New York: Abrams, 1990), 120; and Goodrich, *Winslow Homer,* 162.

18. Elizabeth Johns, *Winslow Homer: The Nature of Observation* (Berkeley: University of California Press, 2002), 138–40, 156. On Maury (1806–1873), see Charles Lee Lewis, *Matthew Fontaine Maury: The Pathfinder of the Seas* (Annapolis: U.S. Naval Institute, 1927); John Walter Wayland, *The Pathfinder of the Seas: The Life of Matthew Fontaine Maury* (Richmond, Va.: Garrett & Massie, 1930); Frances Leigh Williams, *Matthew Fontaine Maury, Scientist of the Sea* (New Brunswick: Rutgers University Press, 1963); Chester G. Hearn, *Tracks in the Sea: Matthew Fontaine Maury and the Mapping of the Oceans* (New York: McGraw-Hill, 2002).

19. Matthew Fontaine Maury, *The Physical Geography of the Sea and Its Meteorology,* 8th ed., edited by John Leighly (1855, 1861; reprint, Cambridge: Harvard University Press, 1963), 38. On Maury's precursors in studying the Gulf Stream, see Louis DeVorsey Jr., "Wayward Ocean River," *Geographical Magazine* (April 1980): 501–10. "Under the brilliant skies of the Florida Straits," DeVorsey observes, "the visual attributes of the Gulf Stream are easily perceived."

20. Maury did not exaggerate the scope of the Gulf Stream. By modern estimates, the water travels at speeds up to five knots through the Florida Straits, around Key West, and up the Atlantic coast toward Cape Hatteras. "More than thirty million cubic meters of seawater flow in the Florida Current every second, a multiplication of Mississippis. The flow increases downstream: the water transported by the Gulf Stream off the Canadian Maritimes is on the order of two hundred million cubic meters—two hundred million bathtubfuls—per second. That far exceeds the combined flow of all the rivers

in the world: the great-grandfather of waters!" William H. MacLeish, *The Gulf Stream: Encounters with the Blue God* (Boston: Houghton Mifflin, 1989), 16.

21. Letter of 1902, quoted in Cikovsky, *Winslow Homer,* 120. A slightly different transcription appears in Goodrich, *Winslow Homer,* 162. I have changed Cikovsky's "they ladies" to Goodrich's "these ladies."

22. See the suggestive review by John Seelye of John Wilmerding's *Winslow Homer,* in *New Republic,* January 20, 1973, 27–29.

23. Nicolai Cikovsky makes an interesting general observation regarding Homer's remoteness in the 1890s that leaves the door ajar for this sort of revisionist interpretation, tying the artist to the world around him in powerful ways:

Homer's late paintings seem remote from the life of his time, just as he himself chose to live remotely from it. Subjects like fishing and hunting or seascapes, places like the coast of Maine, the tropics, and the Canadian wilderness are in every way—what they depict and where they were made—distant from the great social and political events of his age. And yet, as his paintings of the early 1890s suggest, Homer could be, perhaps because of his very distance from it, a sensitive and intelligent analyst of his time. While in the 1860s and 1870s he had observed his age at closer range and had depicted the textures of its manners and appearance in more detail, in later life he depicted it with greater—with keener and subtler—critical penetration and a more synthetic, connective understanding; a penetration that perceived deep meanings and an understanding that joined experience and ideology to forge, beginning with his great paintings of the 1890s, grand symbolic and even iconic images that were, as his contemporaries sensed, by far the clearest and most forceful figurations of their age. To that extent they were, in the nature of their meaning and address, paintings engaged in the public life of their time. (Cikovsky, *Winslow Homer,* 119)

24. R. W. Stallman, *Stephen Crane: A Biography* (New York: George Braziller, 1968), 244. At least seventy American filibustering expeditions had been organized to aid Cuba's insurrection against Spain. More than two dozen had succeeded in eluding the cutters patrolling Florida's coasts to enforce U.S. neutrality, but many vessels never made it to Cuba. In January 1896, for example, the steamer *J. W. Hawkins* sank in a storm in the Gulf Stream, and

more than half of its crew was lost. On actual storms over Cuba, see Louis A. Pérez Jr., *Winds of Change: Hurricanes and the Transformation of Nineteenth-Century Cuba* (Chapel Hill: University of North Carolina Press, 2000).

25. John J. Johnson, *Latin America in Caricature* (Austin: University of Texas Press, 1980), chaps. 4 and 5. Also see Kristin L. Hoganson, *Fighting for American Manhood: How Gender Politics Provoked the Spanish-American and Philippine-American Wars* (New Haven: Yale University Press, 1998).

26. Philip C. Beam notes: "There is ample evidence that Charles Savage Homer was always fussing with someone or something. During the summer of 1898," the old man and an elderly neighbor "telegraphed daily to the War Department that the Spanish fleet had just been sighted off the coast of Maine; and they continued to send these messages up to the day the fleet was sunk in Santiago Harbor." Philip C. Beam, *Winslow Homer at Prout's Neck* (Boston: Little, Brown, 1966), 44.

27. Quoted in Willard B. Gatewood Jr., *"Smoked Yankees" and the Struggle for Empire: Letters from Negro Soldiers, 1898–1902* (Urbana: University of Illinois Press, 1971), 21.

28. William J. Schellings, "Key West and the Spanish-American War," *Tequesta* 20 (1960): 25–26.

29. Gatewood, *"Smoked Yankees,"* 23–24.

30. Ibid., 25. See also Willard B. Gatewood Jr., "Negro Troops in Florida, 1898," *Florida Historical Quarterly* 49 (July 1970): 1–15.

31. Hugh Honour, *The Image of the Black in Western Art,* vol. 4, pt. 2 (Cambridge: Harvard University Press, 1989), 202; see also vol. 4, pt. 1, 91–92. "Tornadoes had," Honour points out, "been described in literature, most notably in William Cowper's famous poem, as acts of divine judgment on slave owners." In Cowper's "The Negro's Complaint," composed in 1788 and published in 1792, the English abolitionist poet wrote:

Is there, as ye sometimes tell us,
 Is there one who reigns on high?
Has he bid you buy and sell us,
 Speaking from his throne the sky? . . .

Hark! He answers—wild tornadoes,
 Strewing yonder seas with wrecks;

Wasting towns, plantations, meadows,
　Are the voice with which he speaks.
He, foreseeing what vexations
　Afric's sons should undergo,
Fix'd their tyrants' habitations
　Where his whirlwinds answer—No.

32. John Hope Franklin with Alfred A. Moss Jr., *From Slavery to Freedom: A History of Negro Americans,* 6th ed. (New York: Knopf, 1988), 234.

33. Stephen Kantrowitz, *Ben Tillman and the Reconstruction of White Supremacy* (Chapel Hill: University of North Carolina Press, 2000), 256–57.

34. Alfred Moore Waddell, "The Story of the Wilmington, N.C., Race Riots," *Collier's Weekly,* November 26, 1898, 4.

35. Kantrowitz, *Ben Tillman,* 257; H. Leon Prather, *We Have Taken a City: Wilmington Racial Massacre and Coup of 1898* (Cranbury, N.J.: Associated University Presses, 1984). Also see the important centennial volume, *Democracy Betrayed: The Wilmington Race Riot of 1898 and Its Legacy,* ed. David S. Cecelski and Timothy B. Tyson (Chapel Hill: University of North Carolina Press, 1998).

36. H. Leon Prather, "The Origins of the Phoenix Racial Massacre of 1898," in *Developing Dixie: Modernization in a Traditional Society,* ed. Winfred B. Moore Jr., Joseph F. Tripp, and Leon G. Taylor Jr. (New York: Greenwood Press, 1988), 59–72; Daniel Levinson-Wilk, "The Phoenix Riot and the Memories of Greenwood County," *Southern Cultures* 8 (winter 2002): 29–55. See also W. Fitzhugh Brundage, "The Darien 'Insurrection' of 1899: Black Protest during the Nadir of Race Relations," *Georgia Historical Quarterly* 74 (1990): 234–53.

37. Wood and Dalton, *Winslow Homer's Images of Blacks,* 104–6. For a recent summary of the Hamburg Massacre, see Philip Dray, *At the Hands of Persons Unknown: The Lynching of Black America* (New York: Random House, 2002), 123, 485n. The episode, Dray explains, "was a noted incident in late-Reconstruction America, its infamy nearly on a par with Custer's Last Stand, which it followed by two weeks, and was seen to symbolize a growing posture of federal nonintervention in Southern affairs."

38. Charles W. Chesnutt, *The Marrow of Tradition* (1901; reprint, Ann Arbor: University of Michigan Press, 1969), 248, 274. Recently, Wilmington citizens

formed the 1898 Foundation with the hope of erecting a monument in 1898 Memorial Park "in a community effort for remembrance and reconciliation." See www.spinnc.org/1898/ (accessed August 10, 2003).

39. Willard B. Gatewood Jr., *Black Americans and the White Man's Burden, 1898–1903* (Urbana: University of Illinois Press, 1975), 197–98.

40. Walter White, *Rope and Faggot: A Biography of Judge Lynch* (1928; reprint, New York: Arno Press, 1969), 231.

41. Among many important books relating to these matters, see Jacquelyn Dowd Hall, *Revolt against Chivalry: Jessie Daniel Ames and the Women's Campaign against Lynching* (New York: Columbia University Press, 1979); W. C. Handy, *Father of the Blues: An Autobiography,* ed. Arna Bontemps (New York: Macmillan, 1941); Adam Gussow, *Seems Like Murder to Me: Southern Violence and the Blues Tradition* (Chicago: University of Chicago Press, 2002); James Allen, Hilton Als, John Lewis, and Leon Litwack, *Without Sanctuary: Lynching Photography in America* (Santa Fe, N.M.: Twin Palms, 2000). This last volume and a related exhibit inspired an impressive three-day conference with hundreds of scholars at Emory University in 2002 devoted entirely to the subject "Lynching and Racial Violence in America."

42. James Weldon Johnson, *The Autobiography of an Ex-Coloured Man* (1913), quoted in White, *Rope and Faggot,* 155. (Walter White dedicated his book to Johnson.)

43. Leon F. Litwack, *Trouble in Mind: Black Southerners in the Age of Jim Crow* (New York: Knopf, 1998), 282.

44. Gatewood, *Black Americans and the White Man's Burden,* 198.

45. Dray, *At the Hands of Persons Unknown,* 3–16, 124–25. On Felton, see LeeAnn Whites, "Love, Hate, Rape, Lynching: Rebecca Latimer Felton and the Gender Politics of Racial Violence," in *Democracy Betrayed,* ed. Cecelski and Tyson, 143–62.

46. Dray, *At the Hands of Persons Unknown,* 10–16.

47. Litwack, *Trouble in Mind,* 283. "What a spectacle America is exhibiting today," a black leader told a protest rally in Boston several weeks later. "Columbia stands offering liberty to the Cubans with one hand, . . . but with both feet planted on the neck of the negro."

48. It is worth noting that the particularly violent storms that arise suddenly in Caribbean waters are known universally as "white squalls." (In 1996,

Ridley Scott directed a Hollywood movie about such a storm, entitled *White Squall,* starring Jeff Bridges.)

49. Wood and Dalton, *Winslow Homer's Images of Blacks,* 41–46. Significantly, another artist working alongside Homer at *Harper's* was Thomas Nast, the father of American political cartooning. Both young men joined other illustrators of the age in perfecting this form of subtle visual commentary. Over time, Nast turned in one direction, making his symbolism increasingly pointed and concrete, in the manner of a cartoonist; Homer turned in the other direction, using more discreet symbolic references suitable for an artist.

50. James R. Grossman, "A Chance to Make Good, 1900–1929," in *To Make Our World Anew: A History of African Americans,* ed. Robin D. G. Kelley and Earl Lewis (New York: Oxford University Press, 2000), 351. "In some cases," Grossman writes, "whole communities were forced from their homes."

51. Kantrowitz, *Ben Tillman,* 157–62. For studies of whitecapping, see the articles of William F. Holmes: "Whitecapping: Agrarian Violence in Mississippi, 1902–1906," *Journal of Southern History* 35 (1969): 165–85; "White-capping in Georgia: Carroll and Houston Counties, 1893," *Georgia Historical Quarterly* 64 (1980): 388–404; "Moonshiners and Whitecaps in Alabama, 1893," *Alabama Review* 34 (1981): 31–49.

52. Blair Lynne Murphy, " 'A Right to Ride': African American Citizenship, Identity, and the Protest over Jim Crow Transportation" (Ph.D. diss., Duke University, 2003).

53. "*Plessy v. Ferguson,*" 163 U.S. 537, 16 S.Ct. 1138, 41 L.Ed. 256 (1896).

54. On February 6, the Treaty of Paris ending the Spanish-American War was ratified by the U.S. Senate. Through this treaty Spain ceded Puerto Rico, Guam, and the Philippines to the United States, and turned over Cuba to U.S. control.

55. For Web links to the poem, contemporary cartoons, and scores of related American editorials, see " 'The White Man's Burden' and Its Critics," ed. Jim Zwick, http://www.boondocksnet.com/ai/kipling/ (accessed August 10, 2003), part of a larger website, "Anti-Imperialism in the United States, 1898–1935."

56. *Southwestern Christian Advocate,* March 9, 1899, quoted in Litwack, *Trouble in Mind,* 153.

57. John Gabriel Stedman, *Narrative of a Five Years Expedition against the Revolted Negroes of Surinam,* transcribed for the first time from the original 1790 manuscript and edited by Richard Price and Sally Price (Baltimore: Johns Hopkins University Press, 1988), 34.

CHAPTER THREE
The Past: Looking Back toward Slavery

1. Philip C. Beam, *Winslow Homer at Prout's Neck* (Boston: Little, Brown, 1966), 141.

2. Ibid., 45, 46, 136; Lloyd Goodrich, *Winslow Homer* (New York: Macmillan, 1944), 195.

3. Beam, *Prout's Neck,* 137. Regarding Wright's death, Beam records: "During the summer of 1925, a very old man, he could no longer carry on, and the Homer family was deeply saddened when they received a telegram . . . from his wife informing them that their old friend and servant was dead" (139). Had he been born in the same year as Homer (1836), this "very old man" would have been eighty-nine at the time of his death.

4. Ibid., 138.

5. Ibid., 137. The circumstances of the death of Wright's son remain unclear, though it would certainly be relevant to know the date and nature of the accident.

6. Philip C. Beam, "Exhibition Checklist of Paintings and Drawings," in exhibit catalog from the Memorial Art Gallery of the University of Rochester, *Winslow Homer in the 1890s: Prout's Neck Observed* (New York: Hudson Hills Press, 1990), 129.

7. Beam, *Prout's Neck,* 138–39. According to Beam: "Even Lewis, of whom Homer was particularly fond, was careful to keep out of the studio during working hours; the artist used to hand him dirty dishes through the window so he would not have to come inside. The year-round residents at Prout's, too, took care not to disturb him at work" (186).

8. Peter H. Wood and Karen C. C. Dalton, *Winslow Homer's Images of Blacks: The Civil War and Reconstruction Years* (Austin: University of Texas Press, 1988), 21–38.

9. Mary Cable, *Black Odyssey: The Case of the Slave Ship* Amistad (New York:

Viking, 1971); William Lee Miller, *Arguing about Slavery: John Quincy Adams and the Great Battle in the United States Congress* (New York: Vintage: 1995).

10. Albert J. Von Frank, *The Trials of Anthony Burns: Freedom and Slavery in Emerson's Boston* (Cambridge: Harvard University Press, 1998).

11. Wood and Dalton, *Winslow Homer's Images of Blacks,* 18–20.

12. William Howe Downes, *The Life and Works of Winslow Homer* (Boston: Houghton Mifflin, 1911), 22. Two weeks after *Harper's* carried the *Wildfire* story from Key West, Homer's journal published a lurid tale entitled "A Shark! A Shark!" about a vessel like Uncle Jim's, trading in Caribbean waters. An illustration drawn by one of Homer's fellow artists showed the climactic scene of the short story, in which ravenous sharks devour a young man who has fallen from a small boat. *Harper's Weekly,* June 16, 1860, 380–81.

13. Gordon Hendricks, *The Life and Work of Winslow Homer* (New York: Abrams, 1979), 44.

14. *The Shackled Slave* (oil on canvas), in the collection of Mr. and Mrs. Paul Mellon, appears in ibid., 56.

15. Wood and Dalton, *Winslow Homer's Images of Blacks,* 58–65.

16. Leon F. Litwack, *Been in the Storm So Long: The Aftermath of Slavery* (New York: Knopf, 1979), vii. Storm imagery also figures in the title of another excellent recent book on slavery: William Dusinberre, *Them Dark Days: Slavery in the American Rice Swamps* (New York: Oxford University Press, 1996).

17. When we were serving together on the board of the Highlander Center, Mrs. Septima P. Clark, the distinguished South Carolina educator and civil rights leader, told me that she could recall from her childhood the cry of the fishmen hawking shark meat in the streets of black Charleston on Saturdays. She was born in Charleston in 1898, and her father, Peter Porcher Poinsette, grew up under slavery. He later worked for the Clyde Line aboard the passenger ships that went up and down the coast between New York and Florida. Quite possibly he crossed paths with a passenger named Winslow Homer at some point.

18. Adam Jones, *German Sources for West African History, 1599–1669* (Wiesbaden: Franz Steiner Verlag GMBH, 1983), 114, 236.

19. Ibid., 236.

20. Alexander Falconbridge, *An Account of the Slave Trade on the Coast of Africa* (London: James Phillips, 1788), 31.

21. George Francis Dow, *Slave Ships and Slaving* (1927; reprint, Cambridge, Md.: Cornell Maritime Press, 1968), 71; see also 11, 262.

22. Ibid., 261–62.

23. Jacqueline Jones, Peter H. Wood, et al., *Created Equal: A Social and Political History of the United States* (New York: Longman, 2003), 130–31.

24. "Narrative of a Voyage from London to the West Indies, 1714–1715," add. 39946, p. 12, British Museum. I am indebted to my colleague Barry Gaspar for this reference.

25. Herman Melville, *Moby-Dick,* ed. Harrison Hayford and Hershel Parker (New York: W. W. Norton, 1967), 252–54. See also Edward S. Grejda, *The Common Continent of Men: Racial Equality in the Writings of Herman Melville* (Port Washington, N.Y.: Kennikat, 1974), 103–7; and Karen M. Adams, "Black Images in Nineteenth-Century American Painting and Literature: An Iconological Study of Mount, Melville, Homer and Mark Twain" (Ph.D. diss., Emory University, 1977), 84–85.

26. Awnsham and John Churchill, *Collection of Voyages and Travels,* 5 vols. (London, 1732), 5:225–26.

27. For the link to Barbot's description in Churchill, see Alan Dugald McKillop, *The Background of Thompson's Seasons* (Minneapolis: University of Minnesota Press, 1942), 129, 165.

28. James Thompson, "Disasters in Tropical Seas," in *The Seasons,* rev. ed. (London, 1744), 97, lines 1002–14:

> Increasing still the Terrors of these Storms,
> His Jaws horrific arm'd with threefold Fate,
> Here dwells the direful Shark. Lur'd by the Scent
> Of steaming Crouds, of rank Disease, and Death,
> Behold! he rushing cuts the briny Flood,
> Swift as the Gale can bear the Ship along;
> And, from the Partners of that cruel Trade,
> Which spoils unhappy *Guinea* of her Sons,
> Demands his share of Prey, demands themselves.
> The stormy Fates descend: one Death involves
> Tyrants and Slaves; when strait, their mangled Limbs
> Crashing at once, he dyes the purple Seas
> With Gore, and riots in the vengeful Meal.

29. Hugh Thomas, *The Slave Trade: The Story of the Atlantic Slave Trade, 1440–1870* (New York: Simon & Schuster, 1997), 489–90; James Walvin, *Black Ivory: A History of British Slavery* (Washington, D.C.: Howard University Press, 1994), 16–21.

30. Jack Lindsay, *J. M. W. Turner: His Life and Work* (Greenwich, Conn.: New York Graphic Society, 1966), 189–90: "It was characteristic of Turner that he should find a great aesthetic release through an image which concentrated his social thinking and at the same time was deeply embedded in the poetic tradition he so loved." See also p. 247, n. 22: "In youth Turner planned an apocalyptic *Water Turn'd to Blood.*"

31. For Thackeray, writing as Michael Angelo Titmarsh, see *Fraser's Magazine* (June 1840). For Ruskin, see Ruskin, *Modern Painters,* 5 vols. (London, 1843), 1:571–73. For an extended and powerful modern discussion of the painting, see Marcus Wood, *Blind Memory: Visual Representations of Slavery in England and America, 1780–1865* (New York: Routledge, 2000), 41–77.

32. Chauncey Brewster Tinker, *Painter and Poet: Studies in the Literary Relations of English Painting* (Cambridge: Harvard University Press, 1938), 151.

33. Adolph S. Cavallo, ed., *Museum of Fine Arts, Boston: Western Art* (Greenwich, Conn.: New York Graphic Society, 1971), 202. For Thackeray and Ruskin, see note 31 above.

34. "Turner's *Slave Ship* [was], at one time, in the collection of John Taylor Johnston in New York. One of the largest and finest American collections at the middle of the nineteenth century, it was regularly open to the public, and its sale in 1876 occasioned much attention." Nicolai Cikovsky Jr. and Franklin Kelly, *Winslow Homer* (New Haven: Yale University Press, 1995), 369–70.

35. Julia deWolf Addison, *The Boston Museum of Fine Arts* (Boston: L. C. Page, 1910), 85–86. Five figures proved more than any American artist's work could command; the Metropolitan bought George Inness's *Delaware Valley* for $8,100 that same year. The Turner purchase seemed even more extravagant because the Boston Museum had just decided to move to a new site in 1899 and was collecting funds to pay for a twelve-acre lot in the Fenway with frontage on Huntington Avenue, where the Museum of Fine Arts now stands.

36. Gordon Hendricks, "The Flood Tide in the Winslow Homer Market," *Art News* (May 1973): 69–71. Clarke, who had purchased *Eight Bells* for $400,

sold it in the 1899 sale for $4,700. Other Homer paintings sold there included *Watching the Tempest* ($370), *Coast in Winter* ($2,725), *The Lookout* ($3,200), and *The Life Line* ($4,500).

In the 1940s, agricultural businessman John Spoor Broome bought *Lost on the Grand Banks* from his grandmother. By 1998, when Broome sold the painting in a private sale, it was the last Homer seascape remaining in private hands. The new purchaser was said to be William H. Gates, chair of the Microsoft Corporation, and the price was well over $30 million, setting a record for an American painting.

37. Downes, *The Life and Works of Winslow Homer,* 135.

38. The 1975 blockbuster movie *Jaws* did not create American culture's fascination with sharks; it sprang from it. The endless succession of shark documentaries since then has only reinforced the fixation.

39. Chewing sugarcane remains commonplace in the West Indies and also in communities in North America, such as parts of New York City, where there are high concentrations of immigrants from the Caribbean.

40. Patti Hannaway, *Winslow Homer in the Tropics* (Richmond, Va.: Westover, 1973), pls. 10, 13, 12. Hannaway dates *Study for "The Gulf Stream"* 1885–86 (165), but Hendricks, *The Life and Work of Winslow Homer,* is undoubtedly correct to list 1898–99 (313).

41. Goodrich, *Winslow Homer,* 161–62.

42. In recent years corn sugar and artificial sweeteners have undercut sugar production. In the summer of 2002, the Cuban government announced the permanent closing of 71 of the country's 156 remaining sugar mills. Some of the idled sites are being made into historical museums to serve Cuba's rapidly expanding tourism industry. "In the Cuban Countryside, a Shift from Sugar," story on National Public Radio by reporter Tim Gjelten, August 8, 2002. Despite sugar's demise, songs and music linked to the crop, such as "Going to a Sugar Harvest" and "Wild Cane Seed," remain highly popular in Cuba, as a subsequent NPR story made clear (October 18, 2002).

43. In the Sea Islands of South Carolina and Georgia, and elsewhere during slavery times, babies placed in the shade while their mothers worked in the fields were weaned and pacified with a cloth sweetened with sugar, known as a "sugar-tit."

44. Sidney M. Greenfield, "Plantations, Sugar Cane and Slavery," in "Roots

and Branches: Current Directions in Slave Studies," ed. Michael Craton, *Historical Reflections* 6 (summer 1979): 115–16. Films concerning blacks in the New World have often made powerful use of sugarcane imagery, as in *The Last Supper, Plantation Boy, Sounder,* and *Burn!*

45. Michael Craton, "The Historical Roots of the Plantation Model," in *Empire, Enslavement and Freedom in the Caribbean* (Princeton, N.J.: Markus Weiner, 1997), 1–32.

46. Ira Berlin, *Many Thousands Gone: The First Two Centuries of Slavery in North America* (Cambridge: Harvard University Press, 1998), 96.

47. Jones, *German Sources for West African History,* 112, 227, 233, 322. I am grateful to Stephanie Smallwood for introducing me to the Jones translation of German sources and for additional insights into the slave trade. She is part of the new generation of Atlantic historians who will soon give us a fuller comprehension of the slave trade than was once deemed possible. See Stephanie Ellen Smallwood, "Salt-Water Slaves: African Enslavement, Forced Migration, and Settlement in the Anglo-Atlantic World, 1660–1700" (Ph.D. diss., Duke University, 1999).

48. Alan Taylor, *American Colonies* (New York: Viking, 2001), 206, 210; see also Richard S. Dunn, *Sugar and Slaves: The Rise of the Planter Class in the English West Indies, 1624–1713* (Chapel Hill: University of North Carolina Press, 1972).

49. Sidney W. Mintz, *Sweetness and Power: The Place of Sugar in Modern History* (New York: Viking, 1985). In his frontispiece, Mintz quotes the observation of an Atlantic traveler in the 1770s: "I do not know if coffee and sugar are essential to the happiness of Europe, but I know well that these two products have accounted for the unhappiness of two great regions of the world: America has been depopulated so as to have land on which to plant them; Africa has been depopulated so as to have the people to cultivate them."

50. Taylor, *American Colonies,* 210.

51. In the 1890s, Cuban sugar received frequent coverage in U.S. newspapers. In Europe, sugar beets had gradually displaced sugar from the Caribbean, and Cuba had grown increasingly dependent on selling almost all of its expanding sugar production to purchasers in the United States. By 1894 Cuba's annual crop had reached one million tons for the first time, but it plummeted again in the following years as a result of tariff disputes, nationalist insurgency, and strikes among the cane cutters. See Louis A. Pérez Jr.,

Cuba and the United States: Ties of Singular Intimacy, 2nd ed. (Athens: University of Georgia Press, 1997), 55–81.

52. Taylor, *American Colonies,* 211.

53. Ruth Mellinkoff, *The Mark of Cain* (Berkeley: University of California Press, 1981), figs. 1, 2 (from Oxford), 19, 20 (from Cambridge).

54. Robin Blackburn, *The Overthrow of Colonial Slavery, 1776–1848* (New York: Verso, 1988), 139.

55. Sidney Kaplan and Emma Nogrody Kaplan, *The Black Presence in the Era of the American Revolution,* rev. ed. (Amherst: University of Massachusetts Press, 1989), 174. For an introduction to Wheatley, see David Grimsted, "Phillis Wheatley: Speaking Liberty to the 'Modern Egyptians,' " in *The Human Tradition in the American Revolution,* ed. Nancy L. Rhoden and Ian K. Steele (Wilmington, Del.: Scholarly Resources, 2000), 307–28; or the same author's fuller piece, "Anglo-American Racism and Phillis Wheatley's 'Sable Veil,' 'Lengthen'd Chain,' and 'Knitted Heart,' " in *Women in the Age of the American Revolution,* ed. Ronald Hoffman and Peter Albert (Charlottesville: University Press of Virginia, 1989), 338–444.

56. Roger Rosenblatt, *Black Fiction* (Cambridge: Harvard University Press, 1974), 54, 63.

57. Quoted in Beam, *Prout's Neck,* 172, without citation.

58. Goodrich, *Winslow Homer,* 226.

59. Bruce Robertson, *Reckoning with Winslow Homer: His Late Paintings and Their Influence* (Bloomington: Indiana University Press, 1990), 27. Robertson goes on, as others have, to give examples of these progressions and to suggest that the "most appropriate analogy is with film making, also a sequence of images that tell a story. Homer approached his subjects as though reshooting them. Thinking always in terms of the relationship between works, as well as the individual work, Homer invites us to consider groupings that may be separated by date of execution or size" (28–30). (He might also have added "separated by medium," as in this case of a watercolor and an oil.) For some of the best-known groupings—watercolors painted in the Adirondacks in the 1890s—see Helen A. Cooper, *Winslow Homer Watercolors* (New Haven: Yale University Press, 1986), 162–95.

60. Quotation is from *Harper's Weekly,* April 19, 1873, 314. On the link to Huntington, see Philip C. Beam, *Winslow Homer's Magazine Engravings* (New

York: Harper & Row, 1979), 23. For a related image of a young woman who is clearly a drowning victim, see Homer's illustration for *Frank Leslie's Chimney Corner,* June 24, 1865, in ibid., 139.

61. Jean Gould, *Winslow Homer: A Portrait* (New York: Dodd, Mead, 1962), 267.

62. Hendricks, *Life and Work of Winslow Homer,* 285.

63. Cooper, *Winslow Homer Watercolors,* 215–17. Cooper cites Leslie Fiedler's observation regarding blacks in American literature: "In the dreams of white men, psychologists tell us, the forbidden erotic object tends to be represented by a colored man . . . [a symbol] for the primitive world which lies beyond the margins of cities and beneath the lintel of consciousness." Concerning the lone figure, she points out: "His legs are concealed by the remains of the stern and rudder, which Homer arranged to suggest an enormous tail or fin, thereby giving the overall contour of man and wrecked boat the form of a huge aquatic creature."

64. Martin Luther King Jr., "I Have a Dream" (speech delivered in Washington, D.C., on August 28, 1963). Homer, along with a limited number of whites in America in his generation, had "come to realize," as Dr. King would later state on the steps at the Lincoln Memorial, "that their destiny is tied up with our destiny and their freedom is inextricably bound to our freedom. We cannot walk alone."

Index

Homer, Charles Savage, Sr. (father),
5, 24–25, *26*, 28, 44, 61–64, 99
(n. 46), 106 (n. 26)
Homer, Henrietta Benson (mother),
5, 8, 25–28
Homer, Henry (uncle), 25
Homer, James (uncle), 67
Homer, Winslow
career: apprenticeship, 7, 67; birth
and death, 5; childhood, 5, 25,
28, 66, 99 (n. 46); Civil War,
7, 9, 20, 64, 70; comments on
The Gulf Stream, 41, 42, 81, 87;
election to National Academy
of Design, 8; familiarity with
certain art works, 77–78,
97 (n. 26); illustrator for
Harper's Weekly, 7–8, 9, 35,
67; independent artist, 8;
photography, 24; popularity,
5, 93–94 (n. 4); Prout's Neck,
Me., 24, 33, 52, 103 (n. 12); sale
of pictures, 80, 113–14 (n. 36);
visits to Florida, the Bahamas,
and the Caribbean, 27, 40, 47,
72, 81, 84, 90; visit to England
(Yorkshire coast), 40, 103 (n.
12); visit to France, 8; visit to
Virginia, 39–40
characteristics as an artist:
ambiguity, 88, 90; the gaze, 11,
95 (n. 5); linked images, 88,
90, 116 (n. 59); photography,
8, 103 (n. 12); portrayals of
blacks, 11, 13, 23, 34–41, 64;
reversed images, 73; themes,
8–13; versatility, 7; visual puns,
53; watercolors, 8, 40
works: *Arguments of the Chivalry*,
67; *Army of the Potomac—A
Sharpshooter on Picket Duty*,
9, *10*; *Basket of Clams, A*, 30;
*Bivouac Fire on the Potomac,
A*, 35, *36*; *Blossom Time in
Virginia*, 39; *Boys in a Pasture*,
11; *Busy Bee, The*, 39; *Cannon
Rock*, 52; *Cotton Pickers*, 40;
"Dad's Coming!" (engraving),
25, *29*; *Dad's Coming* (oil), 25;
*Defiance—Inviting a Shot before
Petersburg*, 9; *Dressing for the
Carnival*, 40, 48; *1860–1870*, 70,
71; *Fair Wind, A* (or *Breezing
Up*), 11; *Fishing Boats, Key
West*, 40; *Fog Warning, The*,
80; *Hurricane, Bahamas*, 21, *22*;
Leaping Trout, 80; *Life Line, The*,
97 (n. 24); *Lookout—All's Well,
The*, 80; *Lost on the Grand Banks*,
114 (n. 36); *Near Andersonville*,
37, *39*, 40; *Northeaster*, 52; *Our
Watering Places—The Empty
Sleeve at Newport*, 9; *Pay-Day
in the Army of the Potomac*, 53;
Prisoners from the Front, 9, 16;
Rum Cay, 40; *Search Light on
Harbor Entrance, Santiago de
Cuba*, 44; *Shackled Slave, The*, 70;
Shell in Rebel Trenches, A, 35, 37,
38, 102 (n. 8); *Slave Deck of*

Wheatley, Phillis, 85; "On Being Brought from Africa to America," 86

White, Walter, 49–50

"whitecapping," 54–55, 74, 109 (n. 51)

whitecaps, 52–55

"White Man's Burden" (Kipling), 56, 109 (n. 55)

"white squall," 32, 108–9 (n. 48)

Williams v. *Mississippi,* 49

Wilmington, N.C., 47–49, 107 (n. 35)

Winslow Homer (Cikovski and Kelly), 28, 30

Winslow Homer (Johns), 23

Winslow Homer at Prout's Neck, (Beam), 62, 64

Winslow Homer's Images of Blacks (P. Wood and Dalton), 34

Wood, Marcus, 3–4

Wood, Peter H., 1–2, 23, 30–31, 34, 39, 53

Worcester Museum, 13

Wrecked Schooner, The (W. Homer), 21

Wreck of the "Atlantic"—Cast Up by the Sea, The (W. Homer), 89

Wreck of the Hesperus (Longfellow), 88

Wright, Lewis, 25, 61–62, *63,* 64, 110 (nn. 3, 5, 7)